BRITAIN IN OLD PHOTOGRAPHS

CW00540243

DONCASTER
SHOPS & STREETS
THROUGH THE LENS OF LUKE BAGSHAW

PETER TUFFREY

The
History
Press

This book is dedicated to the memory of Alan Smith whose help and encouragement in the early years of my career was invaluable.

First published 2009

The History Press
The Mill, Brimscombe Port
Stroud, Gloucestershire, GL5 2QG
www.thehistorypress.co.uk

British Library Cataloguing in Publication Data.
A catalogue record for this book is available from the British Library.

ISBN 978 0 7524 4837 4

Typesetting and origination by The History Press
Printed in Great Britain

CONTENTS

ACKNOWLEDGEMENTS

I am indebted to the following people for their help: Malcolm Barnsdale, Eric Braim, John Cuttriss, Ted Day, Philip Langford, Karen Lewington, Martin Limbert, Hugh Parkin, Alan Smith, Tristram Tuffrey, Robert Walter, and Peter Young.

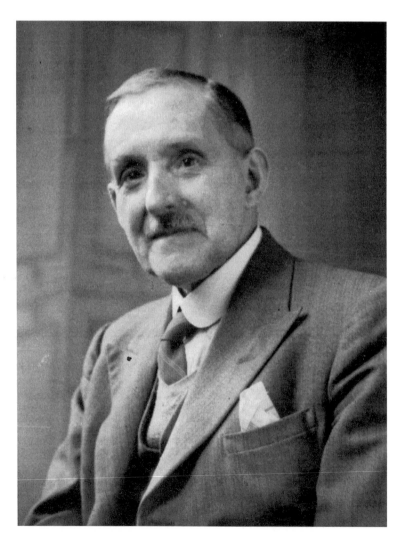

Luke Bagshaw
(1875–1944).

INTRODUCTION

Between 1894 and 1930 Luke Bagshaw photographed almost every major constructional development in Doncaster. Consequently, for those people today who think the French Gate Centre, Colonnades, Waterdale Shopping Precinct, Northern and Southern bus stations, high rise flats, roundabouts and ring roads have been part of the townscape for years, his photographs are a revelation.

For those who remember Doncaster pre-1960 his photographs are immensely nostalgic and support a popular feeling in the town that its appearance over the last fifty years has, perhaps, not changed for the better.

Luke probably had no idea that in future years his work would have such an impact. Like many other photographers of his generation, he merely considered that taking photographs was part of a day's work.

Luke Bagshaw was born in Doncaster about 1875 and is first noted as a photographer in 1894, operating from his parents' Union Street home.

SMALL STUDIO

As Luke's confidence and custom grew, his father, John Thomas Bagshaw, an astute businessman, established the photographic firm of Bagshaw & Son in 1897. John Thomas involved himself only with the administration of the business and left the photographic work to his son and assistants.

The business was first carried on in a small studio at the foot of Hexthorpe Bridge. As the firm expanded and began to deal in photographic materials, more space was required. Consequently, during the autumn of 1898, Bagshaw & Son moved to larger premises in St Sepulchre Gate.

Initially Luke lived at the shop with his parents and brother but moved out following his marriage in 1902. At this period 'bread and butter' work for Luke was portrait photography. He even employed a canvasser to tour the district obtaining orders. Luke knew all the tricks of portrait work and frequently 'improved' or made alterations to a person's photograph.

After taking some portrait photographs of Lady Halifax at Hickleton Hall her husband wrote to Luke commenting: 'There is just something about Lady Halifax's mouth in the sitting position which might be much improved.' Luke must have resorted to drastic measures since in a further letter Lord Halifax states: 'The photograph you have done of Lady Halifax, substituting the new head, is quite excellent and I think that you are a genius. It could not be better.'

As well as portrait photography, Luke obtained custom from all the district's prominent employers: Doncaster Corporation, railway companies, brewers, architects, estate agents, shopkeepers and the gentry. The work undertaken for Doncaster Corporation included recording street widening schemes as well as major construction work like the building of the North Bridge. Tasks undertaken for the private sector ranged from photographing shop window

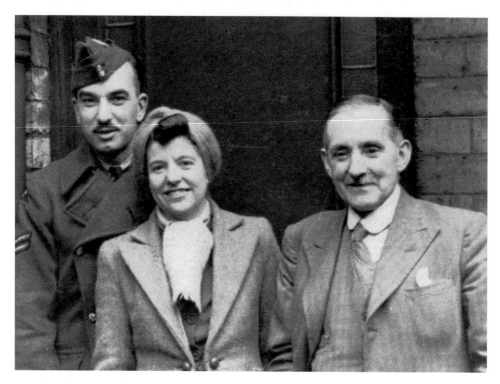

Luke Bagshaw, right, his daughter Blanche and his son-in-law Robert Walter.

Arthur Pinkey and present author, Peter Tuffrey.

displays for Hodgson & Hepworth, the grocers, to construction work on the Dearne Valley Railway's viaduct at Conisbrough.

COMMISSIONED

Luke's photographs, however, can rarely be judged from an artistic point of view since the rigid instructions of the people who commissioned them were always uppermost in his mind (excluding, of course, the picture postcard views he was commissioned to carry out). His photographs nevertheless are important today because they provide a record of the Doncaster area before the changes of the last fifty years.

During the Edwardian period Bagshaw & Son became Doncaster's principal photographic dealers, supplying equipment to the trade and general public. Doncaster's postcard photographers such as E.L. Scrivens and the Jameson Brothers ordered large supplies of materials from the firm, often at short notice. In addition to photography, Bagshaw & Son were involved in selling and repairing phonographs and a further sideline was the provision of magic-lantern projectors and operators for lectures and children's entertainments.

Throughout the First World War, Luke took many photographs of soldiers and their families, which were treasured as keepsakes. Among the most interesting ones he took during this period were of women carrying out war jobs at the plant works. Photographs show the women cleaning carriages, varnishing shells, working on lathes and painting wagons.

John Thomas Bagshaw retired from business in 1924, and died six years later. At the time of his father's death, Luke's eyesight was starting to deteriorate. He had no son to succeed him and carry on the business. However, his two daughters helped in the shop and Miss Alice Harrison, who had joined the firm in 1918, became his chief assistant. One of her tasks involved focussing the cameras once Luke had made the necessary preparations to take the photographs.

During the 1930s photography became more accessible to the general public. People bought their own cameras and with the advent of roll film, taking photographs was made much easier. The demand for portraits subsequently waned and Luke's failing eyesight and general health restricted his involvement with work commissioned by the Corporation and private industry. The business nevertheless provided Luke with a comfortable income until his death in 1944. His widow Blanche continued the firm until 1954, when she leased the premises and goodwill to Miss Harrison.

Blanche died in 1963 and two years later Miss Harrison gave formal notice to the Bagshaw estate of her intention to relinquish the premises, though she subsequently opened another photographic shop, also entitled Bagshaw & Son, on the opposite side of the road. She remained there until 1978 when the photographic business of Bagshaw & Son, synonymous with photography in Doncaster for almost a century, finally ceased to trade.

Surprisingly, many of Luke's glass negatives survive, although they are divided among public and private collections. This assures Luke of a place in Doncaster's photographic history, particularly as the negatives of most of the other major Victorian/Edwardian photographers were destroyed long ago.

ARTHUR PINKNEY

In 1949 Arthur Pinkney, a former camera repairer, was working for Mrs Bagshaw, who asked him to clear out the attic of the St Sepulchre Gate premises. It contained a large amount of old photographic apparatus and numerous boxes of glass-plate negatives. He was instructed to retain anything of use and dispose of the remainder. The most important items that he acquired were over 400 glass-plate negatives depicting views of Doncaster and its neighbourhood dated between 1894 and 1930.

The plates remained in his possession until the 1980s when he sold them to the present author. They are probably the only surviving example of a Doncaster photographer's commercial work from the late Victorian/Edwardian period.

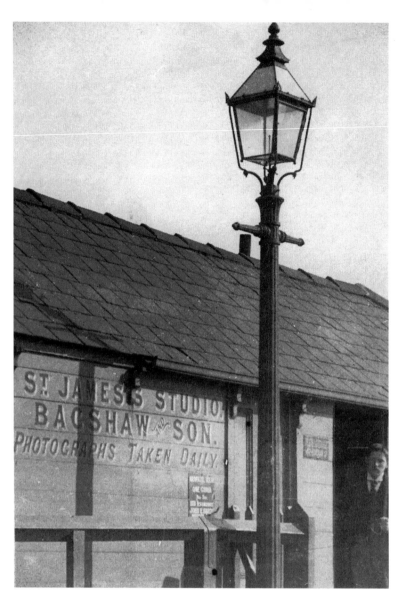

John Thomas Bagshaw was born in Doncaster and as a boy served his apprenticeship as a coppersmith in the Doncaster 'Plant' Railway Works. He later worked in Leeds and Wakefield, returning to Doncaster to become a shopkeeper. He started in a small shop in Cleveland Street, as a tobacconist. In addition to that, he commenced as an agent to the Prudential Assurance Co. From Cleveland Street, he moved to St Sepulchre Gate and then to Union Street. Then, in around 1894, his son Luke Bagshaw became interested in photography, and their photographic business was set up in Union Street. This subsequently transferred to a lock-up wooden studio on St James' Bridge, Hexthorpe, pictured here.

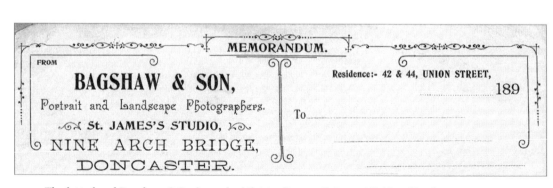

The letterhead Bagshaw & Son's used whilst trading on St James' Bridge, Hexthorpe.

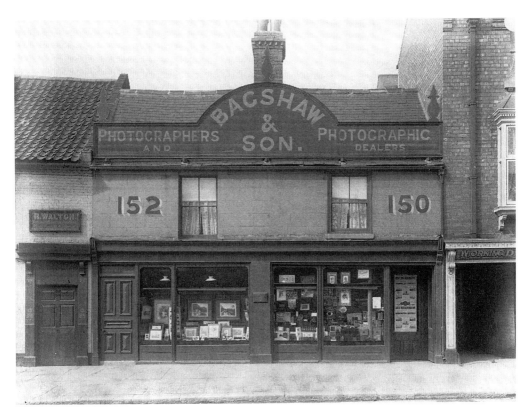

From the St James's Bridge studio, John Thomas Bagshaw and son Luke moved to Nos 150-152 St Sepulchre Gate, near the Horse and Jockey Hotel, and for years were well known and successful in their business as the town's principal photographic dealers. After experiences in many branches of business locally, John Thomas Bagshaw announced his retirement from active participation in the firm during January 1924. He was nearly seventy-eight, and it was claimed that his career was a lesson in determination and enterprise. Between 1965 and 1978 the business was conducted by Alice Harrison in a shop on the opposite side of the street.

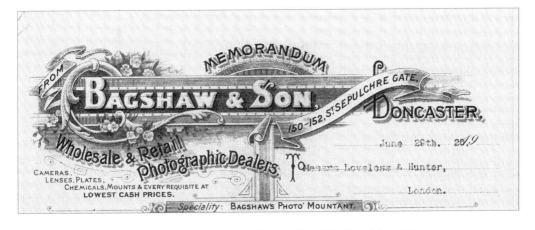

Bagshaw & Son's letterhead for their business at Nos 150-152 St Sepulchre Gate.

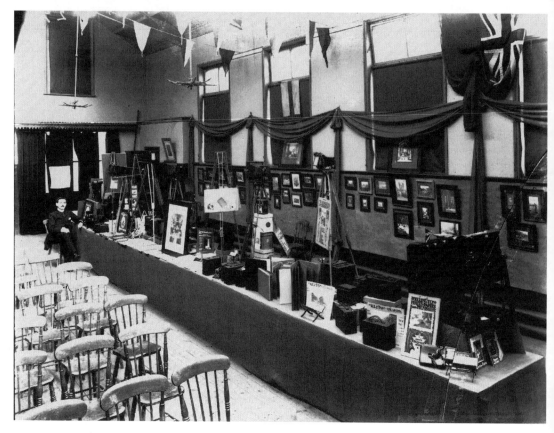

Luke Bagshaw pictured at what is thought to be an exhibition of photographic equipment.

ROBERT WALTER

After examining prints taken from the negatives, purchased from Arthur Pinkney, I realised that their historical content was of sufficient importance to warrant their inclusion in two books. However, I did not consider the historical value to be their only merit; it also seemed desirable to know something of the photographer and of the circumstances under which each picture had been taken.

Some of the documentation for this book was provided by Robert Walter, the son-in-law of Luke Bagshaw. He placed at my disposal a large amount of material, in the shape of letters, account books, bills and receipts as well as a further collection of glass-plate negatives. This was more than sufficient to create a clear picture of the business careers of Messrs Bagshaw & Son.

EDWIN DIXON

Edwin 'Eddie' Dixon, partner in the firm of Dixon, Colcutt & Weston, was responsible for the printing of many of the pictures from the glass-plate negatives. He was one of the only photographers in the area who had an enlarger big enough to take the glass plates. Arthur Pinkey proclaimed Eddie was a real wizard at printing photographs and even went as far as to say it was probably the first time someone had taken the time and effort to print the pictures properly and to their best advantage.

1

COMMERCIAL WORK

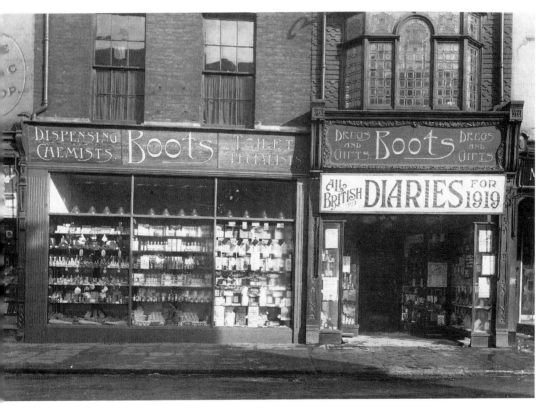

Boots' premises in French Gate. Medical botanist, Jesse Boot, opened his first shop in Nottingham during 1850. Boots first appeared in Doncaster at No. 69 French Gate around 1896. The business moved to No. 71 French Gate in 1908 and ten years later expanded to No. 70. Twenty years after that the company acquired premises in Baxter Gate and developed the new and existing stores into one large one. A new Boots opened in the Arndale (now French Gate) Centre on Friday 25 July 1968.

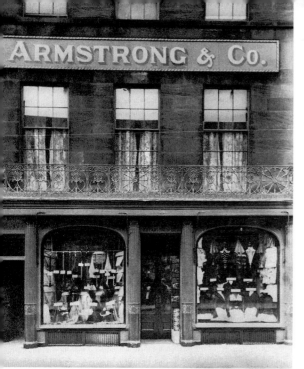

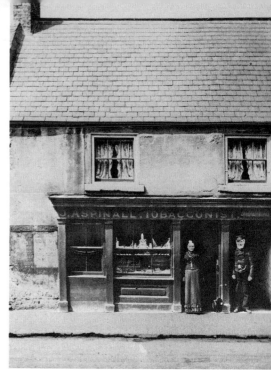

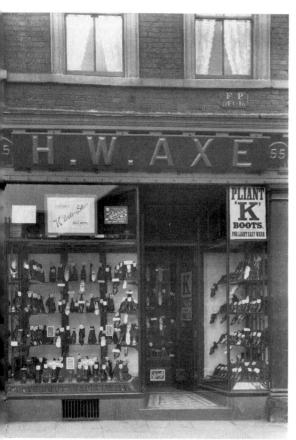

Above left: George Armstrong's business premises in Baxter Gate. Armstrong, who died aged seventy-three on 2 May 1912, was one of the town's leading milliners and drapers and for many years Armstrong was the principal in the firm of Armstrong & Co. A native of Cumberland, he took no part in public life and most of his relatives lived in Cumberland. He married a Miss Nicholson, of Ashfield House Conisbrough, who died in 1908, and they had no family.

Above right: J. Aspinall occupied his St Sepulchre Gate tobacconist shop, pictured here, from at least 1890. In 1905, however, he was served notice by the Corporation that his premises were required to facilitate proposed street improvements. He was given £5 to vacate the building and he subsequently continued his business in West Street. The man in the photograph is standing in the entrance to Pinder's Yard, which was also demolished as a result of the improvement scheme.

Left: H.W. Axe's shop at No. 55, which proclaimed, 'Gents Boots a Speciality.' The advertisements on the window include those for 'K' Boots and Shoes and the Rambler Boot.

John Athron was the son of
James Athron, a member of
the once well-known local firm
of Athron & Gill, contractors.
John was educated at Jackson's
private school in Hall Gate,
and afterwards was associated
with the firm of Athron & Gill,
but eventually commenced
business on his own account
in Park Road in around
1894. The business included
all descriptions of building
work: plain and ornamental,
sanitary and drainage work,
repairing, bricklaying, besides
roofing, plumbing, glazing and
painting. They also produced
monuments, headstones and
memorials.

A fine selection of finished
work in that line was on view
in the yards and show rooms.
Athron died from a heart
attack, aged forty, in 1911.

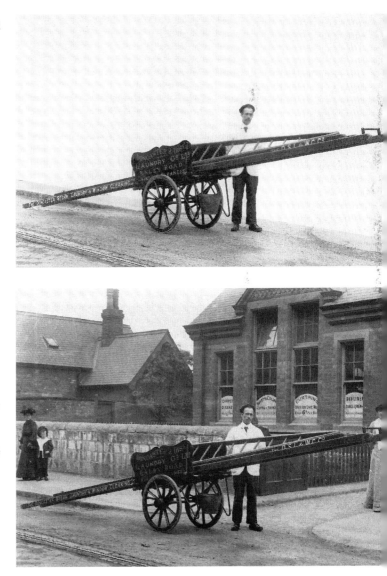

An employee of the Doncaster
& District Steam Laundry &
Window Cleaning Co. is seen
here outside the business
premises, which opened in
1901 in Balby Road. One of the
company's advertisements in
1911 claimed that: 'window
cleaning was carried out by
most competent and reliable
men.' When I first acquired
this plate the background was
painted out so, eager to learn
what was covered up, I carefully
removed the mask. The result
is seen in the top and bottom
pictures 'before' and 'after'. The
background had been masked
out for the image to be used in
an advertisement.

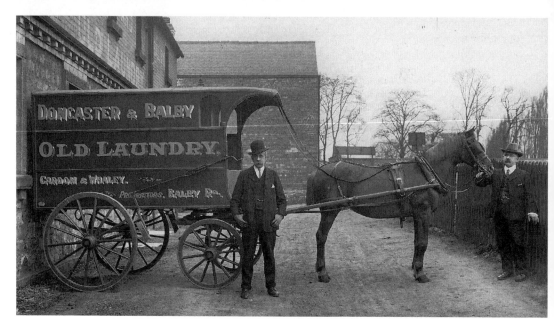

Gardom & Whaley's Doncaster & Balby Laundry opened during the late nineteenth century, operating from an old girl's reformatory, west of Balby Bridge. The business was run by the Gardom sisters, Elizabeth, Sarah, Maggie May and Grace, together with the latter's husband John William Whaley. They were in direct competition with the Doncaster & District Steam Laundry Co. Ltd, but for the first quarter of the twentieth century at least, they seemingly co-existed well enough together. In 1926, however, Gardom & Whaley decided to retire from the laundry business, and a sale notice appeared in the *Doncaster Gazette*. The Doncaster & District Steam Laundry Co. Ltd continued in existence until the building was demolished for redevelopment in around 1970.

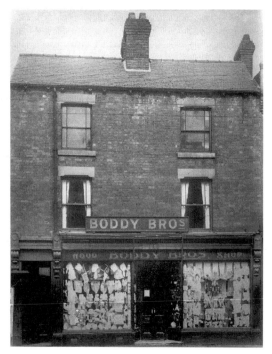

The firm of Boddy Bros was started in 1879 in a small shop at No. 68 St Sepulchre Gate by J.W. Boddy and originally traded in fancy goods. The firm prospered from the start, and in 1888 acquired No. 60 St Sepulchre gate where a gentleman's outfitters was established. J.W. Boddy's three sons Percy, Herbert and J.W. (jnr) were all brought up in the business and in 1896 J.W. jnr opened a further branch in the Market Place. This, however, was closed down in December 1950, and the firm concentrated on the St Sepulchre Gate premises. During the final years of the business, the family concentrated on wool and wool fabrics, and was a household name in Doncaster and the surrounding district. The business premises were disposed of in 1953 due to the retirement of the partners.

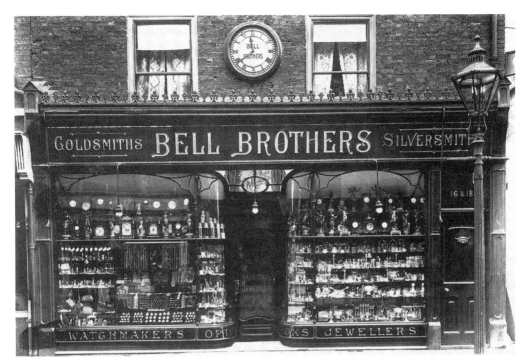

Bell Bros' founder, Joseph Bell, was born in Twickenham and started his seven-year apprenticeship in the watch-making and jewellery trade during 1771 with Messrs John Julian & Sons, of New Brentford. About ten years later, he moved north and began a watch and clock-making business in Bawtry, re-locating to Doncaster a few years later. His first shop was in French Gate, and afterwards he moved to Baxter Gate. Here he remained for several years, and was followed in the profession by his son, James, who had seven sons. Five of these entered their father's business, which transferred to St Sepulchre Gate around 1853. On the death of James Bell, the name of the business was changed to Bell Bros.

E.H. Booth's grocery and provision stores on the Balby Road and Greenfield Lane corner.

15

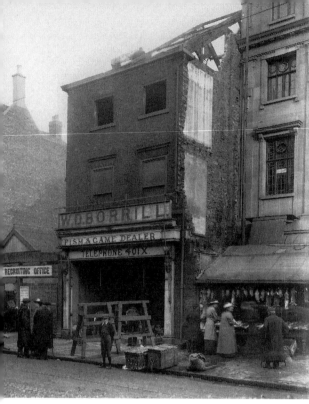

W.D. Borrill was born at Toynton All Saints, Spilsby, Lincolnshire, and moved to Hull with his parents when he was four. He was only eight when his mother died, and three years later the death of his father left him an orphan. An aunt and uncle took him under their care, and he began his career by going to Grimbleby, near Louth, to learn the trade of flour milling and baking. When he was only eighteen he took charge of a mill in Nottinghamshire, and from there went to a flour mill in Doncaster. The firm moved him to Goole for a time, and it was while doing this work that he had the idea of starting a business of his own. He found premises in Copley Road, and began business as a fish and fruit dealer. Alderman and Mrs Borrill lived in Copley Road for twenty-eight years. They also had a larger shop in St Sepulchre Gate. In 1924 Alderman Borril closed it and retired. This was the year that he was Mayor of Doncaster. His career as a member of the town council began in 1909. He was elected by St George's Ward, which he represented continuously until his elevation to Alderman in 1922. In his time he was also chairman of the Markets Committee, vice-chairman of the Estates Committee, and a member of the Aerodrome, Watch and Race Committees.

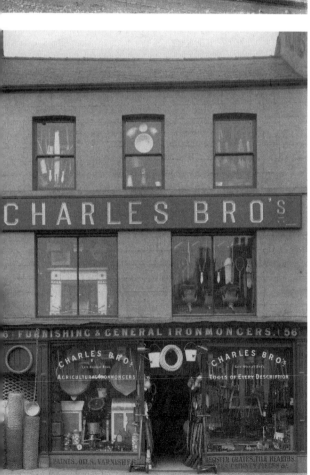

Charles Bros' ironmongers store at No. 56 Market Place. The *Doncaster Gazette* of 19 May 1899 recorded: 'Messrs Charles Bros (late Hockley Bros) have now completed the alteration to their premises,' and this may have been the reason for Luke Bagshaw taking this picture. Hockley Bros had announced they were retiring in the *Doncaster Gazette* of 18 February 1898.

Christ Church Road looking north to the junction with Copley Road. Both pictures were taken for property owner J.W. Chapman who ran a bill-posting company, amongst a number of other businesses. His obituary in the *Doncaster Chronicle* of 4 July 1946 stated: 'John William Chapman was one of the most outstanding men Doncaster has produced within the last two or three generations ... He began without a stick or stone to his name, and ended as a man of wealth and substance and a pioneer in property development.'

Christ Church Road looking southwards to its junction with Nether Hall Road.

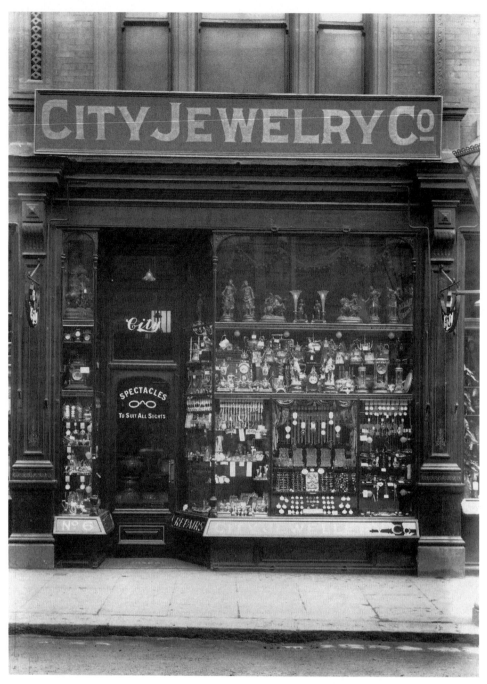

During September 1950 it was announced that E.T. Robinson, of Burghwallis, who was in business in Doncaster with the firm of Messrs Skinner & Robinson, jewellers of French Gate, had taken over the control of two old-established jewellery businesses in the town. They were the City Jewellery Co., of Baxter Gate, seen here, and Messrs Wrights & Shires of St Sepulchre Gate. The actual take-over would be on Monday 25 September. E.T. Robinson said: 'The businesses will be retained under the same names, and with the same staffs. I am anxious to preserve the individuality of these firms.' Wrights & Shires was established in 1863, and the City Jewellery Co. was founded by John Shires in 1897.

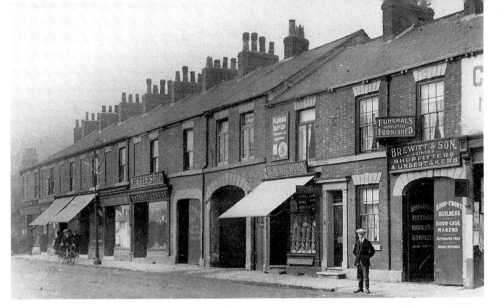

Above: A view of Cleveland Street business premises which includes those of William Nettleship, plumber, gas and water engineer who spent the whole of his business life in the town and was one of the best-known figures in the trading community. He was born at Arksey, where his father was coachman and stud groom at Arksey Hall. He came to Doncaster as a lad to be apprenticed to Walker & Wright, plumbers etc. in St George Gate, and very soon after he set up his own business in Cleveland Street. He remained there until his death, at the age of sixty-one, in May 1915. During that time he had not only done a great deal of work in Doncaster, but reputedly he had been employed on drainage and water works at every country house in the neighbourhood. Two of his sons, Joseph and Cecil, had for some years been in the business as partners, and his eldest son, also called William, was in business on his own at Bridlington.

Below: The Doncaster Mutual Co-operative and Industrial Society Ltd's premises in Conisborough, *c.* 1905. A stone on the building bears the date 1889.

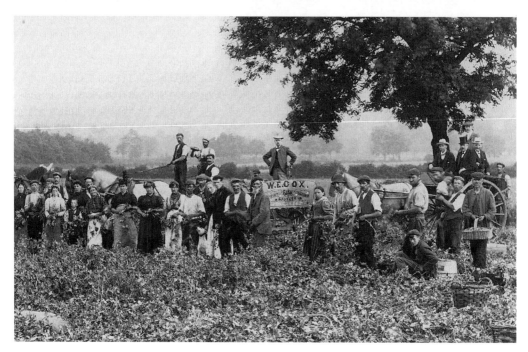

This picture shows pea pullers working for William Edward Cox, who was born in Oxfordshire and came to Doncaster during the 1870s. Initially he worked for Hodgson and Hepworth in St Sepulchre Gate, but he left to establish his own wholesale greengrocery business. He occupied premises in Cemetery Road, then Bentinck Street, moving to a large site in Printing Office Street in around 1904. Cox also owned a farm at Kirk Sandall, the location of these two photographs, taken in 1898. W.E. Cox died in 1920 but his company continued to supply provisions in the Doncaster area until shortly before the Second World War. It was subsequently taken over by J. & J.H. Peters.

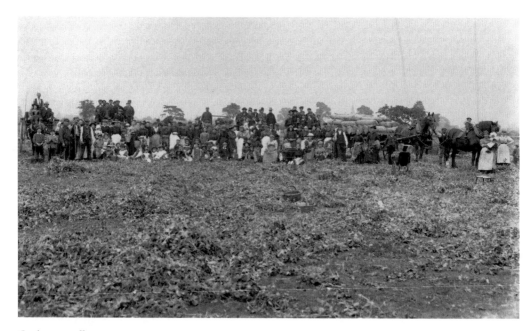

Cox's pea pullers.

Dolphin Chambers (note the dolphins on each side at the top of the premises) in the Market Place. The building once housed the business premises of architects Athron & Beck for whom Luke did a considerable amount of work. The building had formerly existed as the Dolphin Inn from at least 1781 until around 1892, after which time Herbert Athron was noted as buying the premises. The Bijou cinema was formerly housed in a building at the rear.

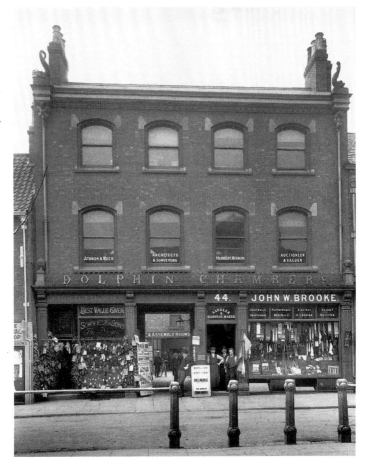

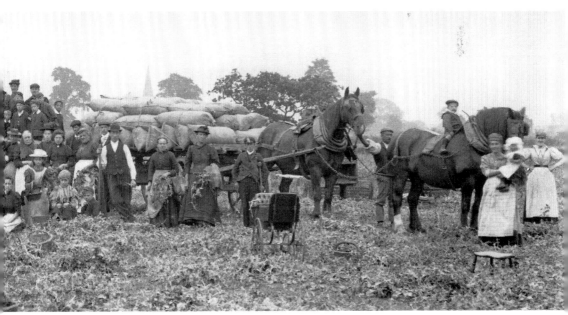

A detail taken from the picture opposite.

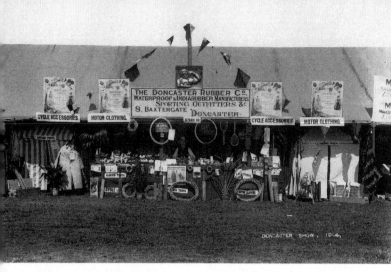

A tent belonging to the Doncaster Rubber Co. at the Doncaster Show of 1904.

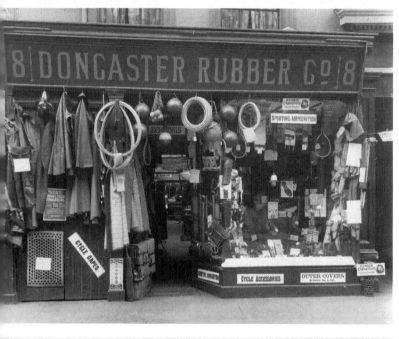

The Doncaster Rubber Co.'s premises at No. 32 Baxter Gate, where John Somers was once recorded as the manager.

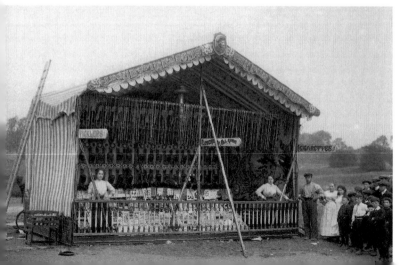

A tent belonging to J. Doubtfires & Sons announcing they are the 'Fun Providers'.

In January 1933 it was announced in the local press that the firm of Drury & Co. of St Sepulchre Gate had closed. Drury & Co.'s premises stood near the entrance of the present French Gate Centre. The founder of the firm, Anthony Drury, had died aged sixty-two in 1931. Though one of the oldest tradesmen in the town, he was not a native of Doncaster. He was the youngest son of George Drury, a farmer at Swinefleet, near Goole. He came to Doncaster when he was about twenty, entering the drapery business of Messrs Addingley. After about five years he bought the business and took in the old Temperance Hall, which was at the rear of the shop, and added it to his already extensive stockrooms. He was joined by his brother George Drury, and George's two sons Ted and Bert were later apprenticed to the firm. Bert remained with the firm until its closure and, it was announced, was to open on his own account in Printing Office Street 'when the St Sepulchre Gate premises had been cleared.'

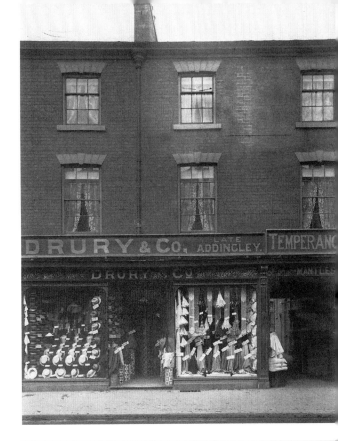

A window of Elland's boot-repairing shop where two advertisements read: 'Gents boots from 2/6 soled and heeled' and 'Ladies boots from 1/6 soled and heeled'. Castleford-born Walter Elland, founder of the Doncaster firm of drapers, W. Elland & Sons, was apprenticed as a boy to the clothing trade and, after experience in various places, he moved to Doncaster in 1900. He started in business in a small way in St James' Street and under his guidance the business grew, moving to No. 123 St Sepulchre Gate and later to a site at the Spring Gardens and St Sepulchre Gate corner. Walter Elland died, aged sixty-eight, in December 1938.

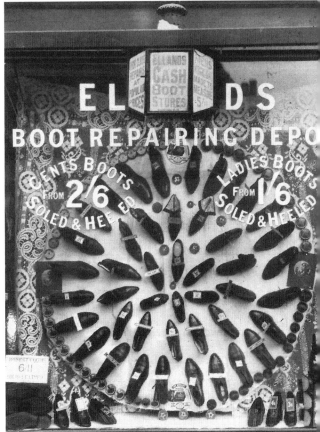

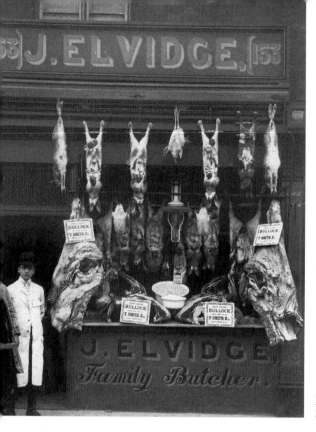

J. Elvidge, family butcher at No. 153
St Sepulchre Gate.

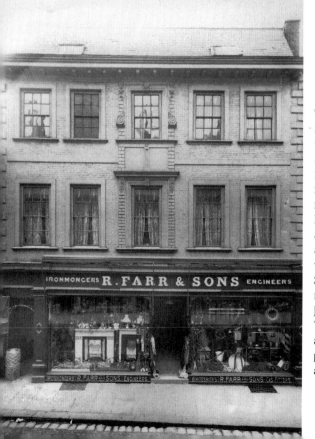

The ironmongery business of R. Farr &
Sons in Baxter Gate. This business spanned
three generations. Robert, born in 1823,
and his brother, inherited the business
from their father. When Robert's brother
retired, Robert took sole control, before he
retired himself in 1893 (some fifty years
later) to be succeeded by his sons Walter
and Percy. Robert was also involved with
agriculture and was closely identified
with the Doncaster Christmas Fat Stock
Show, his successes in the show ring being
numerous. He was also one of the best
judges and breeders of cattle in the district.
Walter and Percy were also involved with
agriculture and became famous for their
pedigree sheep and cattle. Both retired
about 1917.

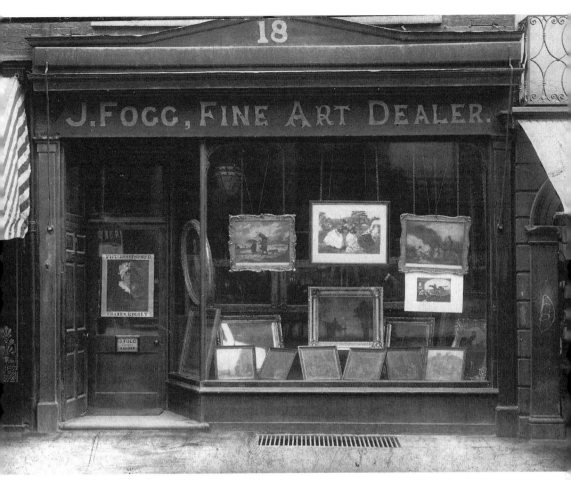

During the early part of the last century, Doncaster boasted a most prominent connoisseur and art dealer, John Fogg, whose shop (pictured here) was at No. 18 High Street. He was born in Doncaster in 1842, and at fourteen was apprenticed to Messrs Brooks & Sons of Doncaster, a firm of art dealers with branches in London and Hull. Four years later, he joined the Volunteers and served with them for a number of years. He moved to London to learn the art business in 1863, returning to Doncaster around 1870 to acquire a business in Scot Lane. Eight years later he moved to premises in High Street which he occupied until his death in 1920. John's clientele included a number of distinguished people, including Edward VII, Earl Fitzwilliam, Lord Galway and Lord Scarborough. A fire at Serlby Hall provided John with the biggest picture-restoring job he ever had: thousands of pounds' worth of pictures were damaged and it took him many months to put them to rights. It was perhaps for his collection of old sporting paintings and engravings that John was best known. Of these, he made a special feature during Race Weeks, usually with excellent business results.

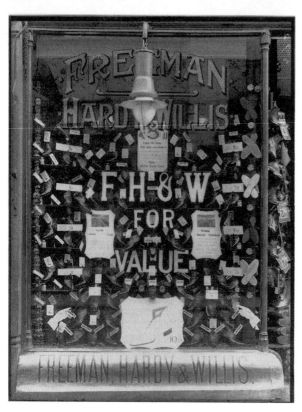

A window display at Freeman, Hardy & Willis. The company's 'boot and shoe' warehouse opened at Nos 30-31 Baxter Gate around 1887. It remained there for many years and was later owned by Sears PLc.

The staff at Freeman, Hardy & Willis's premises pose proudly outside the store where an end of century sale is being announced.

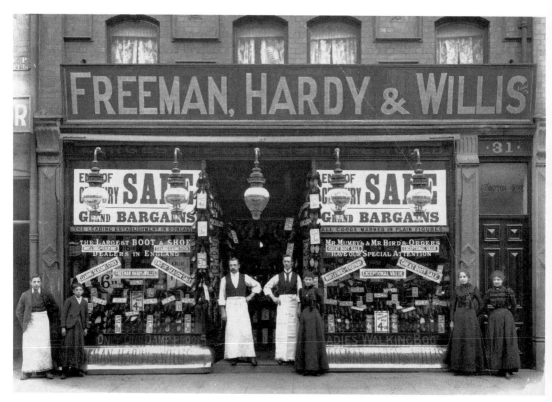

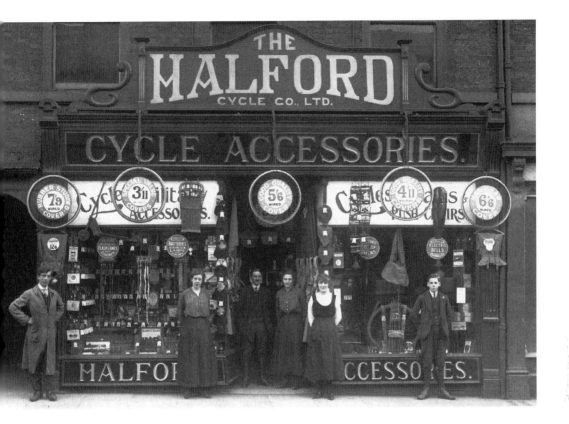

The Halford Cycle Co. Ltd's premises at No. 56 Hall Gate, Doncaster, where the proprietors opened in 1909 as motorcycle and cycle dealers. Nearly seventy years later they transferred to No. 17 Cleveland Street in 1980, the Colonnades in 1986 and North Bridge in 1989.

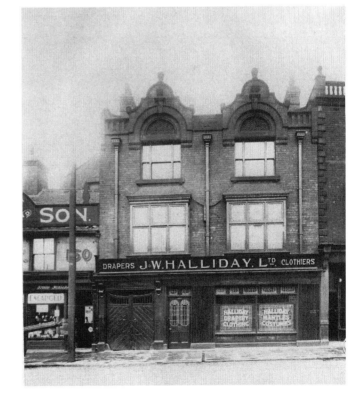

J.W. Halliday Ltd's drapers and clothiers business, which was adjacent to Luke Bagshaw's premises in St Sepulchre Gate.

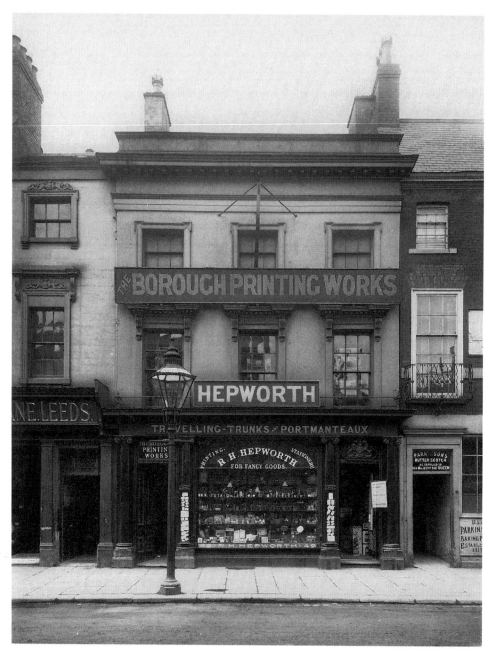

The printing and stationery business in High Street, Doncaster, which was established by Richard Henry Hepworth before the turn of the century. A town councillor for twelve years until 1934, Hepworth represented Central Ward and was mayor in 1928-29. He was appointed magistrate in 1936, and was an income-tax commissioner, a member and past president of Doncaster Conservative Association. Richard had attended regularly to the business until a few weeks before his death aged seventy-nine in 1954. The business was carried on by H.A. (Bob) Hepworth, one of his five sons. Bob retired in 1969 after forty-six years in the business and the premises were let to another firm. Bob said then: 'If I had had someone to leave the business to, I would have kept it going, but I decided to retire while I was still doing well. There is not much room for small family businesses nowadays.'

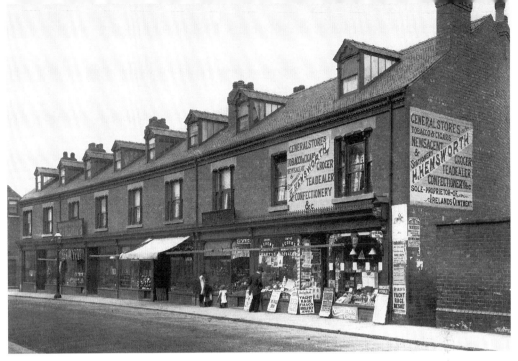

Above and below: These two photographs show views from opposing angles of a stretch of commercial properties between Kirk Street and Flowitt Street, Hexthorpe, including: H. Hemsworth's general store, Haslehirst's fruiters, and Nettleship's grocery and provisions, A.J. Swift's premises and W. Senior's jewellers. The views pre-date the tramway system introduced in 1902. In a *Doncaster Chronicle* article dated 10 September 1953 the following is mentioned about Harry Hemsworth: 'Working in a business founded by his parents, is Harry Hemsworth, a Hexthorpe Road, Doncaster newsagent. Although Mr Hemsworth's mother was widowed in 1922 she carried on working at the shop until she was eighty-five and when she died early this year had reached the fine old age of ninety-one. Now her son is carrying on the family traditions at the shop close to the gates of Doncaster's Railway Plant Works.'

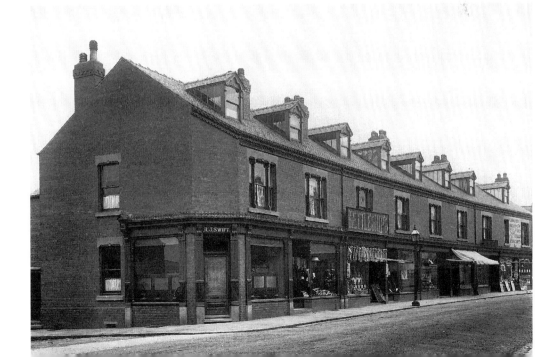

Commercial property on the northern side of Hexthorpe Road, built around 1900, and stretching between Denison Road and Kirk Street. The writing in the white-wash on two of the property's windows indicate they were subsequently occupied by A. Larner, cycle dealer and repairer, and J.S. Skinner & Co., hardware dealers.

Henry Hinchcliffe was born in 1842 and it was said that he was not unlike King Edward VII in general appearance. He came to Doncaster as an assistant in the shop of Mr Mawe (later Sheard, Binnington & Co.), in the drapery department, and remained there until Mawe's retirement in December 1884. Hinchcliffe, along with a Mr Allott, a Wakefield man, entered into partnership and they established the firm of Hinchcliffe & Allott, drapers and mantle makers in premises on High Street. Three years later they moved to Nos 13-14 High Street, spending £2,000 on alterations and fittings. There, they carried on a high-class trade until their retirement in July 1911. Hinchcliffe died in January 1917; Allott, a much younger man than his partner, died some years later.

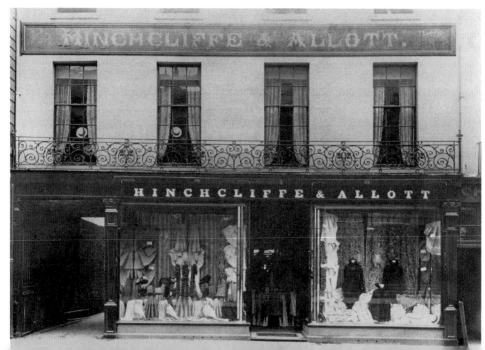

Richard Hodgson and Richard Hepworth probably opened their town-centre shop at Nos 38-40 St Sepulchre Gate in the early 1870s. They sold groceries, provision, bread, confectionary, wines and spirits. In the ensuing years they opened additional shops in Hyde Park, Broxholme Lane and Victoria Street. During the 1890s they opened horse-bus services between their St Sepulchre Gate premises and the outlaying villages. This not only supplied the town with an additional transport service but encouraged people to patronize their shop.

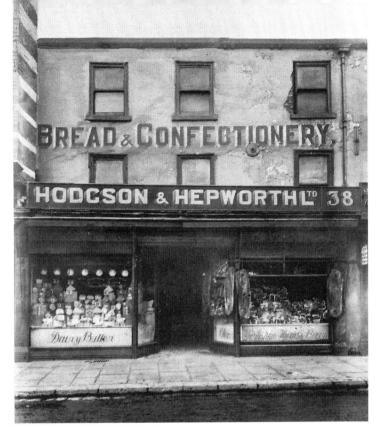

In January 1901 one of Hodgson & Hepworth's buildings, No. 40 St Sepulchre Gate was destroyed by fire. Shortly afterwards it was rebuilt by local builder J. Sprakes & Sons to the designs of architects Athron & Beck and is pictured above. No. 38 (pictured above) was not included in the re-building scheme but was altered in later years. Hodgson and Hepworth's business continued to thrive until recent years, when the town centre stores were demolished for the construction of the Arndale Centre.

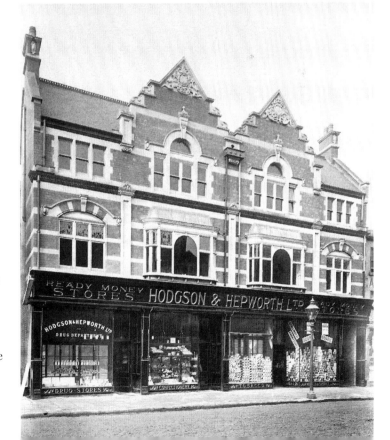

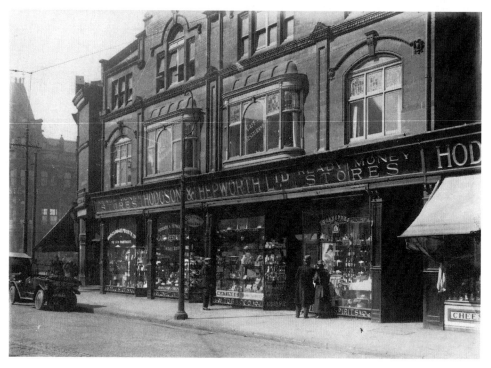

Hodgson & Hepworth's new store with Station Road on the left.

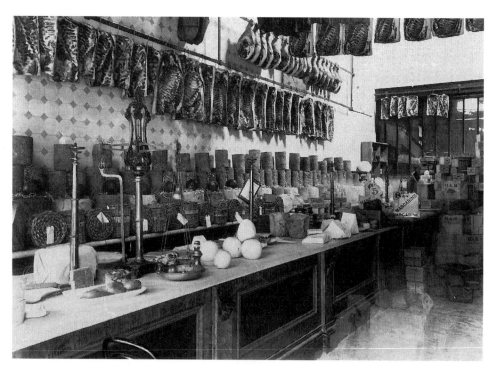

Part of the interior of Hodgson & Hepworth's bakery and provision department, at No. 38 St Sepulchre Gate, *c.* 1901.

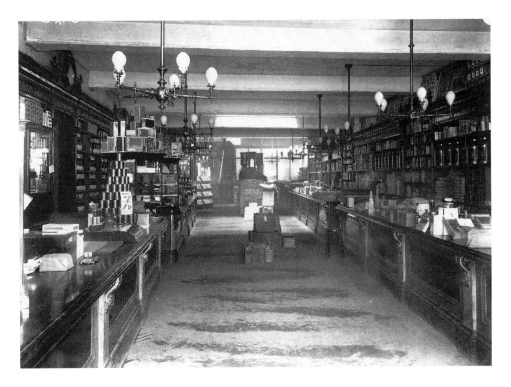

Above and below: The ground floor of Hodgson & Hepworth's new shop, which contained the confectionary, pharmacy and grocery departments, these photographs depict views of the latter.

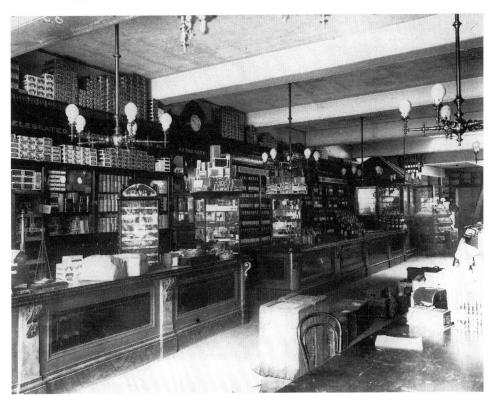

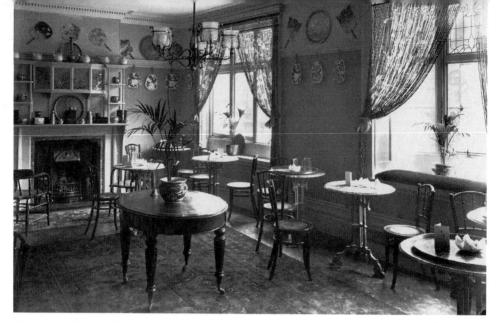

Hodgson & Hepworth's Oriental Café.

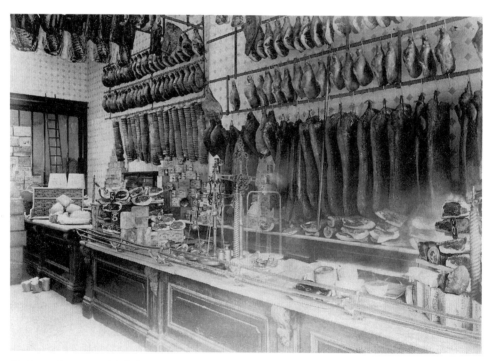

Hodgson & Hepworth's bakery and provision's department. When Hodgson & Hepworth's store closed its doors for the last time on Saturday 1 September 1979, the long-serving members of staff said it was like the break-up of a family. Hodgson & Hepworth's had ceased to be a local family firm in 1948 when a Hull-based firm took it over and a merger in the late 1960s made it part of the national Fine Fare supermarket chain. Dublin-based textile firm, Primark, which was also part of the Fine Fare chain, subsequently moved into the premises vacated by Hodgson & Hepworth.

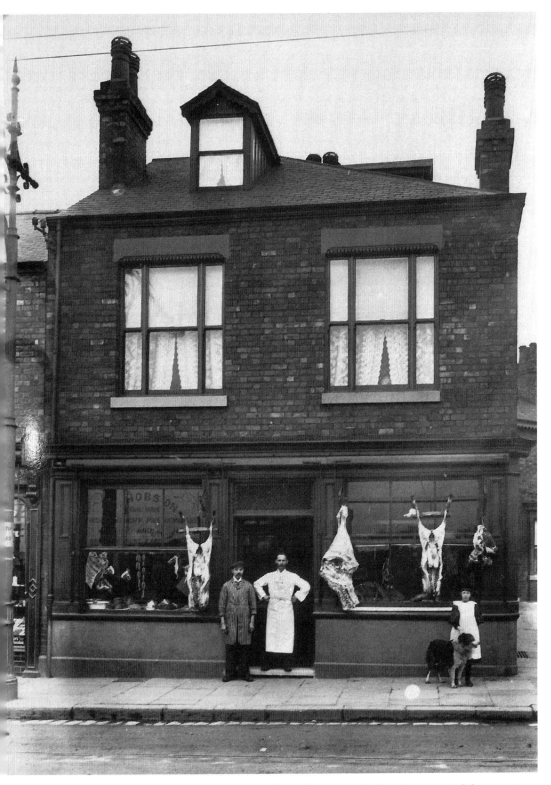

Hobson's butcher's store in St Sepulchre Gate. After Hobson, another butcher occupied the premises. To the right is Arbitration Street.

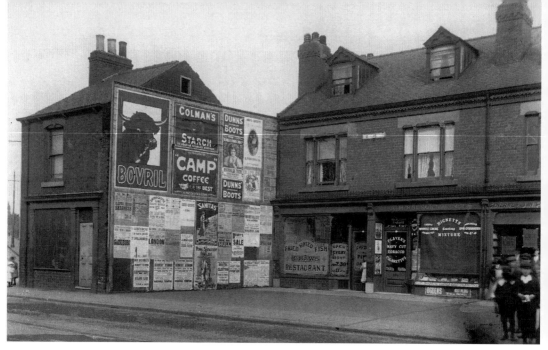

Property in the Holmes Market, Doncaster. The picture was probably taken for the bill-posting business of J.W. Chapman. The traders' premises depicted here include those belonging to Shaw's fish restaurant and A.M. Hodson's tobacconists' shop.

The business premises of Hopkinson Bros in Cleveland Street. In later years the property was occupied by Bernard Cuttriss's model shop.

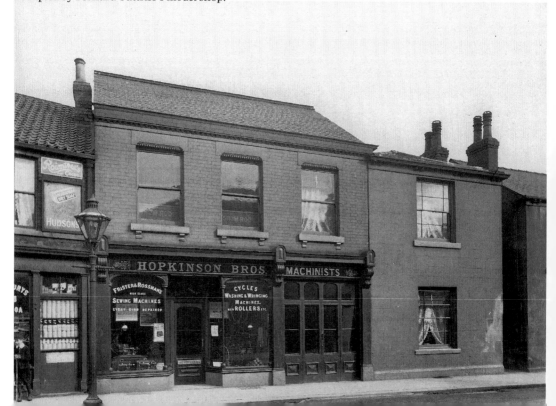

On Saturday afternoon 22 October 1887, four memorial stones were laid on the site of the new Co-operative stores pictured here in Hyde Park, Doncaster, where several hundred people had assembled to witness the stone-laying ceremony. The building stood at the corner of Jarratt Street and consisted of grocery and provision, hardware and butchery stores. The building contract was in the hands of Messrs Arnold & Son. The first part of the ceremony was the presentation of a silver trowel, supplied by Bell Brothers, to the president Mr Rogerson and the stones were laid by E. Yelland, Rogerson, Crawshaw, and Wightman, members of the committee. Wightman placed a bottle underneath the stone, containing a copy of the last quarter's report and of the Co-operative News. The building has since been demolished.

Kellets Successors Ltd's shop at No. 14 St Sepulchre Gate, Doncaster. A sign on the left notes that the firm (a gentleman's outfitters) also has branches in Blackburn, Burton-on-Trent, Huddersfield, Derby, Dewsbury, Keighley, Manchester, and Warrington. In a *Doncaster Gazette* advertisement of 19 March 1920, the company described itself as 'The Artistic Tailors'. The company existed on the St Sepulchre Gate site between about 1909 and 1928, eventually being superseded by Montagu Burton Ltd.

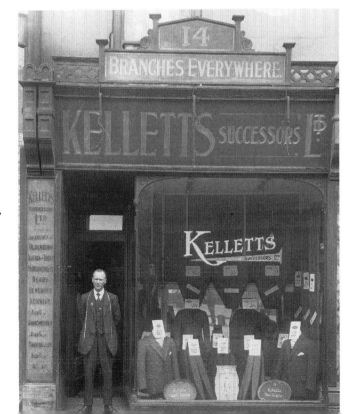

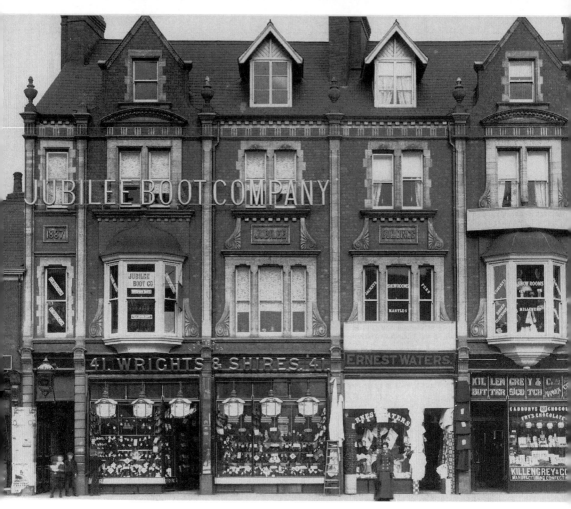

In 1899 boot dealers, Public Benefit, moved from No. 41 St Sepulchre Gate to new premises at the corner of St Sepulchre Gate and Printing Office Street, and their old shop was occupied by the Jubilee Boot Co. This firm may have been a subsidiary of outfitters and boot dealers, Wrights and Shires who occupied No. 29-31 St Sepulchre Gate. The Jubilee Boot Co. remained in business until 1914 when the premises were occupied by curriers, Clark & Sons. In later years, part of the property was acquired by Taylor & Colbridge Ltd to establish their stationery and book business.

Opposite: Killengrey & Co. Ltd's premises in High Street (above) and French Gate (below). The company, manufacturers of butterscotch and other sweetmeats, was formed in the mid-nineteenth century by J. Killengrey, and on 13 April 1897 they purchased premises in French Gate. During the 1890s, the firm employed around 100 hands, turning out fifteen to twenty tons of 'spice' each week. Butterscotch and rock were the two main sweetmeats made; the demand for the latter during the summer months often taxed the resources of the firm to the limit. In 1866, when the Prince of Wales was a guest at the Doncaster Races, the firm presented him with an elaborate box of their butterscotch. It was graciously accepted and permission given to them to use the term 'Royal'. However, by the turn of the century the company was struggling, and in December 1901 the business went into liquidation. These facts were reported in the Doncaster Chronicle of 6 December 1901. But as can be seen from the date in the picture (23 June 1902) the company must have traded for a period of time afterwards.

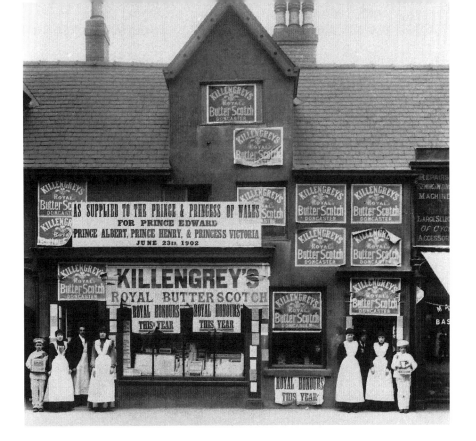

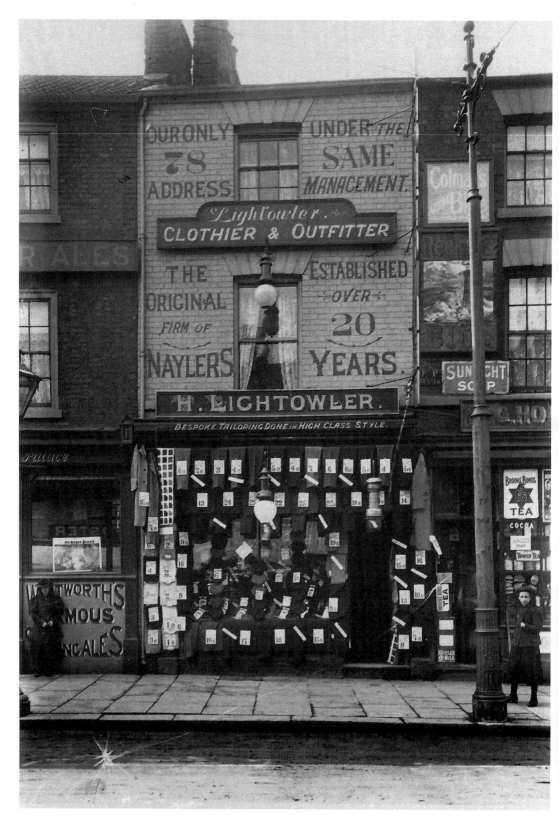

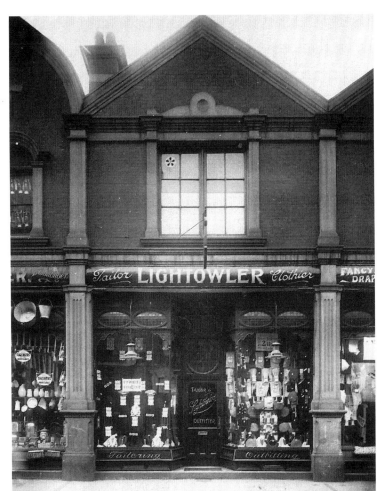

Herbert Lightowler was a tailor and outfitter in Doncaster for many years. He was born in Pontefract in 1873 where his father was County Court Bailiff, and prominent in the Conservative party. Herbert served an apprenticeship with a tailor at Pontefract and came to Doncaster as an assistant in a St Sepulchre Gate business run by a Miss Nayler, whom he married shortly afterwards. Their trade was largely in workingmen's ready-made clothing, navvies being specially catered for, but it also included a certain amount of more expensive attire. Herbert subsequently opened a branch store in Carr House Road and later a high-class tailoring business in Silver Street. He died in April 1933.

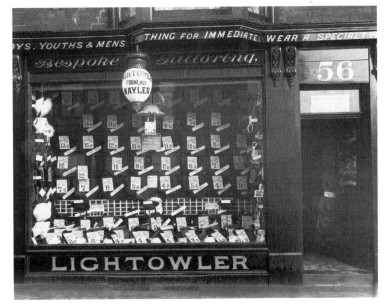

Occupying Nos 1-4 Market Place were Parkin & Son (on the left). This firm of general drapers, upholsterers, cabinet makers and domestic-machinery importers and dealers, was owned by T.E. Parkin whose father, Thomas Parkin, began the business in around 1875 with a small sewing machine shop in French Gate. Part of this shop was required by the Corporation in 1893 for street widening together with the adjacent premises occupied by Horatio Morris, shoemaker. This latter property had earned renown over two centuries earlier as being the reputed site of the assassination of the pro-Republican, Colonel Rainsborough, during the English Civil War. Bagshaw's photograph, taken in 1893, belies none of this earlier drama and shows the area before street widening took place.

Mrs Melbourne's Doncaster business premises.

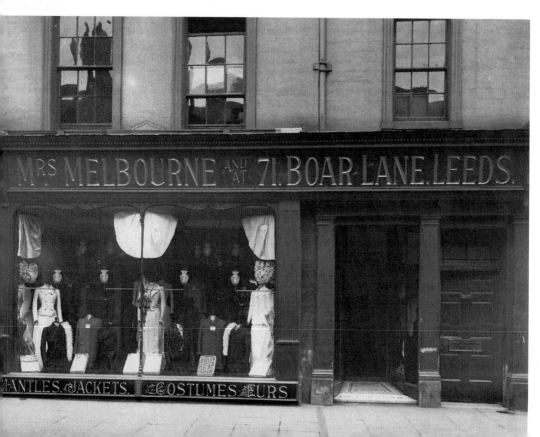

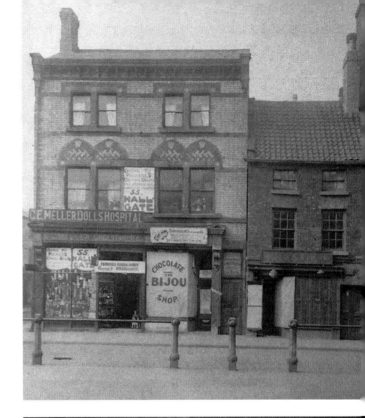

Charles Meller's first shop, a 'dolls' hospital', was opened in Doncaster around 1863. He also ran and undertaking and cabinet-making business with his son Charles Edward (known as Ted). The business' premises were in the Market Place, near the Scot Lane corner, but were demolished due to the Scot Lane widening scheme in around 1927. A new shop was subsequently occupied in Hall Gate. In 1959 Lines Bros of London bought the dolls' hospital when Mr and Mrs Grenville Meller retired. When I interviewed Leila Meller, Grenville's wife, some years ago, she told me: 'I think that father-in-law [Ted] started a toy shop, or more specifically the Doll's Hospital as a result of him buying a huge consignment of damaged dolls. By swapping various limbs and things around he was able to make complete dolls.' Lines Bros of Merton, south west London, who had shops and interests in a number of areas, continued the business for a time, the premises currently being occupied by solicitors Bridge Sanderson & Co.

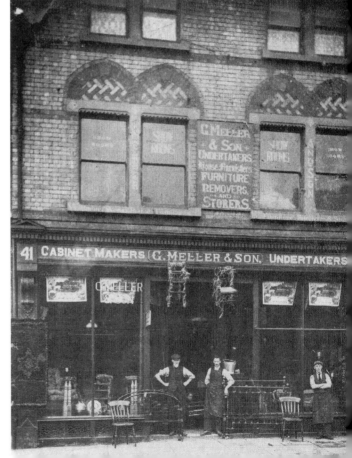

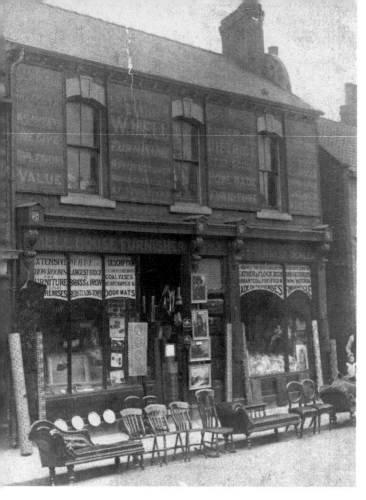

William Mell's furnishing store at Nos 123-125 St Sepulchre Gate.

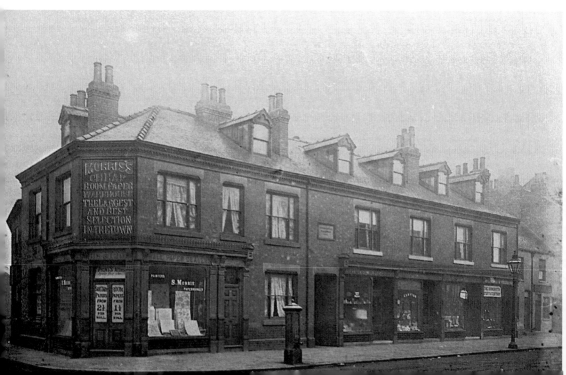

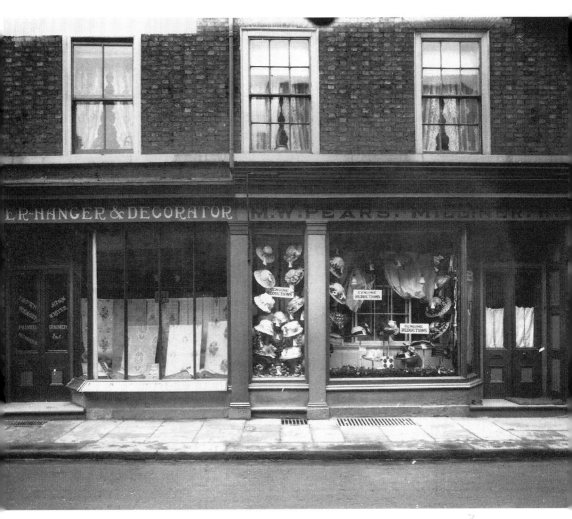

The business premises of M.W. Pears milliner in Scot Lane are seen on the right, whilst those of a paperhanger are on the left. M.W. Pears' business thrived between around 1909 and 1925.

Opposite below: On Monday 4 December 1950 the funeral took place at the Jewish cemetery, Rose Hill, Doncaster, of Samuel Morris, twice mayor of the town, prominent businessman and race-horse owner. He was, for many years, senior partner of S. & H. Morris Ltd, wallpaper manufacturers and retailers, and a director of Wallpaper Manufacturers Ltd, of London and Manchester. At thirteen Morris made his first move, which was to bring him success: he left home in Sheffield to assist in the loading of ponies for his uncle at Hull, but instead of returning home as he should have done, he went to New York in the boat carrying the ponies. He remained in New York for two years, earning $10 a week for exercising race horses and doing general duties as a stable lad before returning to his family in Sheffield. It was shortly afterwards that he made his first appearance in Doncaster, selling wallpaper from a stall in the market. His partner in that enterprise was his brother Hyman Morris who became Lord Mayor of Leeds in 1941-1942. Samuel Morris eventually opened a shop at the West Street and St Sepulchre Gate corner in 1890. The firm expanded and at one time had five shops in Doncaster alone, with another twenty shops in other parts of the country including Blackpool, Boston, Chester, Chestefield, and Crewe. The business survived in Doncaster until recent times.

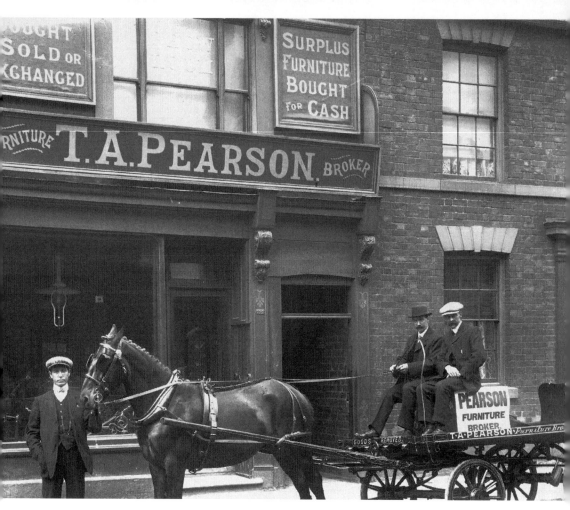

The premises of T.A. Pearson. The *Doncaster Chronicle* of 18 June 1936 announced that T. Andrew Pearson, aged sixty-four, the proprietor of the firm of Doncaster house furnishers, had died at his home in Thorne Road. He began his career as a wheelwright's apprentice at Rossington and from there he went into his father's timber business as manager. At one time they supplied the Doncaster Corporation with timber.

Opposite: Edward Peniston was born at Blyth in 1816, and on leaving school he was apprenticed to his brother-in-law a Mr Jenkinson, grocer and draper of Tickhill. On completing his apprenticeship, he went to Mansfield, where he started on his own account. He came to Doncaster in 1860, and along with Dennis Roberts, established a drapery business in the Market Place. The partnership lasted only a year, when Peniston took control of the entire business. His son William was afterwards taken into partnership, and Edward retired from the business in the early 1880s. William died in 1913 predeceasing his father who died a few months later at the age of ninety-seven. The firm subsequently went through several management changes before closing. Messrs Peniston & Co. were one of the first drapery firms in Doncaster to adopt the modern style of shop windows with corridors on each side of the central window.

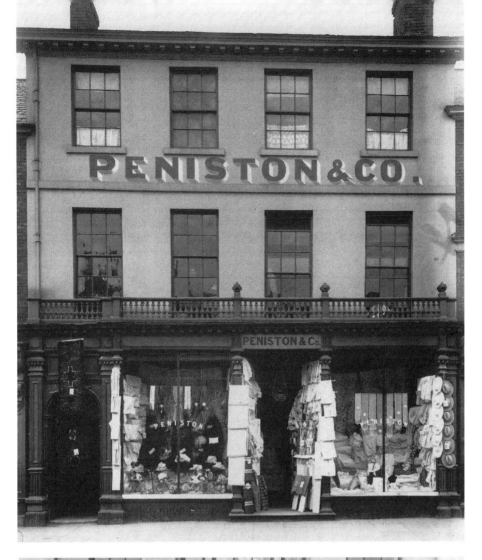

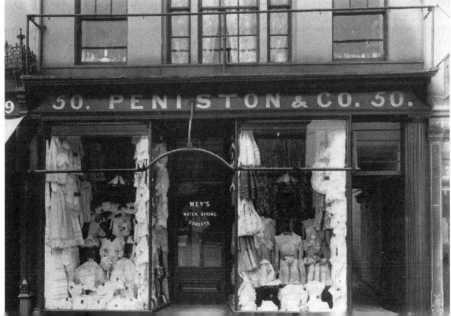

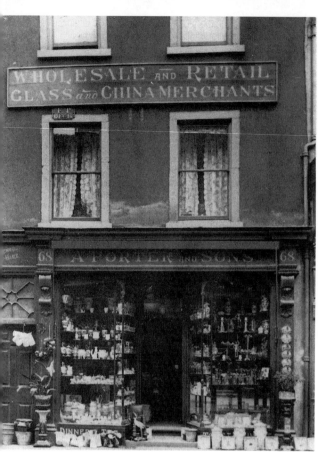

Barnsley-born William Porter, glass and china merchant, originally served his apprenticeship as a bricklayer. In 1872, his mother established the business of A. Porter & Sons at Barnsley. Around 1887, William moved to Doncaster and first opened a business at No. 68 French Gate (shown here) and later in the Market Place. In April 1968, Porter announced his retirement and sold the business. He was sixty-four and had been in the glass and china business in Doncaster for forty-five years.

The Phoenix Firewood Co.'s business premises in Bentinck Street. It operated there for only the short period between 1909 and 1913.

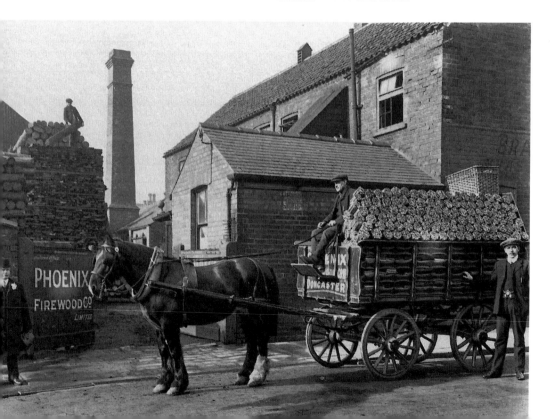

Daniel Portergill's tobacconists. On 15 February 1924 the sad news reached Doncaster that Daniel Portergill had died in Filey 'with tragic suddenness.' He was wheeling a barrow to the station when he collapsed and died. Portergill was formerly a member of the Lincolnshire constabulary stationed at Grimsby after which he came to Doncaster and spent thirteen years occupying premises at the Silver Street and Hall Gate junction. When the corner was redeveloped around 1912 he gave up his shop and went into retirement at Filey.

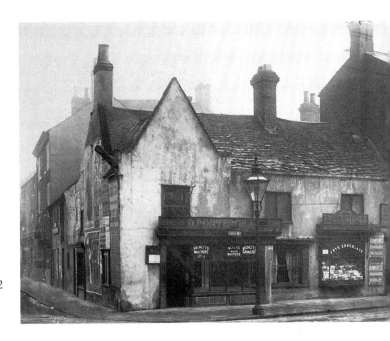

William Poynter's butchers shop at Nos 111-113 St Sepulchre Gate. At the time of his death at the age of eighty-three in June 1930, Poynter was the oldest Doncaster tradesman in business. He was a native of Doncaster, having been born in the Market Place and served his apprenticeship with a John Lamb in a little shop at the bottom of Bentinck Street. He started business on his own account around 1870 in a part of the premises he later owned and occupied. He was also one of the founders of the Doncaster and District Butchers' Association, and held the office of president during the First World War, when he acted as one of the graders of cattle for the government. He also helped to form the Doncaster Hide & Skin Co., afterwards amalgamated with Bradford and other towns. His son, who was in business with him, had died a few years earlier.

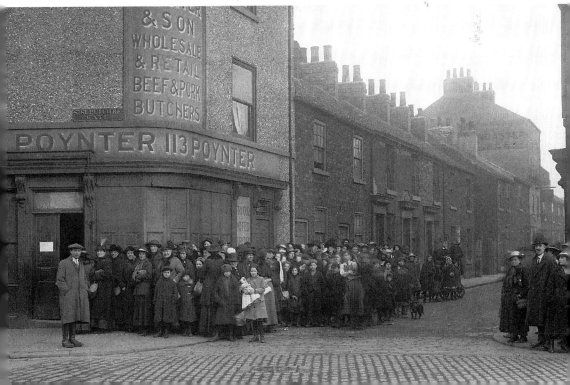

The location of this building is unclear, however it may be the Superintendent's Office of the Prudential Assurance Co. Ltd in Spring Gardens.

The Public Benefit Boot Co. opened its new premises at the Printing Office Street and St Sepulchre Gate corner on Saturday 5 March 1898. Having been set back from Printing Office Street – which was very narrow at this point – to the extent of 7ft 6ins, they formed the first part of a much needed street improvement. The building itself was designed in a free renaissance style of architecture, with a very effectively arranged clock tower on the St Sepulchre Gate side. The premises were designed by Messrs Potts & Sons of Hull and erected by H. Arnold & Son. A special room was arranged for ladies and the whole of the first and second floor areas were utilized for stock rooms.

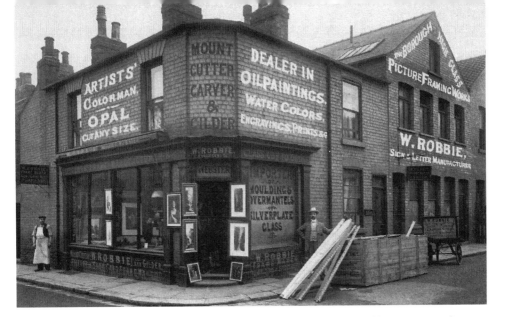

In July 1901, William Robbie, picture frame maker, mount cutter and gilder, importer of mouldings, glass, over-mantels etc, of the Borough Picture Stores took over the business of Thomas Webster at Nos 1-3 Union Street. He boasted that he had the largest and most up-to-date stock of mouldings, and a large variety of framed engravings to select from. And, having practical experience in framing and gilding, was confident he could give the same service as his predecessor. Robbie's new shop was situated a short distance away from Bagshaw's and he was frequently employed by the latter to frame and mount photographs. The white lettering on the brickwork of Robbie's premises was painted on to the negative and did not exist on the walls themselves.

The business premises of Dennis Roberts & Sons at No. 21 St Sepulchre Gate. Dennis Roberts was born in 1811, the son of a farmer and grazier, at Ragnall near Retford. When he was fourteen, his father apprenticed him to Doncaster linen and woollen draper Mathew Wilton. On completing the apprenticeship, Dennis established a drapery business in Everton, near Bawtry. He combined that with selling groceries and tea. About 1840 he returned to Doncaster, taking over a Market Place shop. Dennis's son Walter joined his father in the business in 1873 and they moved to No. 21 St Sepulchre Gate under the new name of Dennis Roberts & Son.

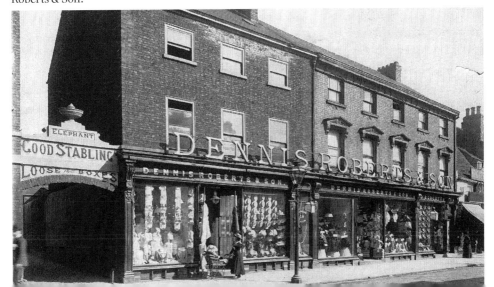

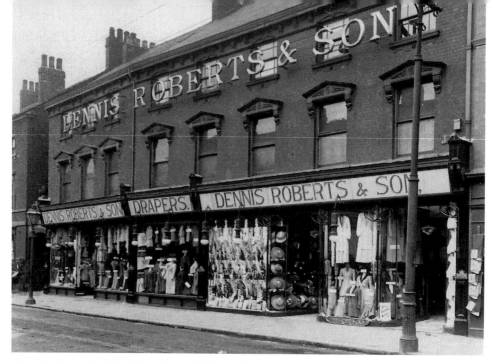

Dennis Roberts died in 1896, his son Walter subsequently ran the business with partners and family members for some time afterwards. The range of activities with which the firm was involved included millinery, drapery, ladies and children's outfitting. One of the firm's slogans was: 'the highest possible excellence, combined with the lowest possible price, guaranteed.'

Walter Roberts died in 1923 and four years later the company ceased trading in St Sepulchre Gate as the Corporation required the premises for street widening. One of the firm's directors, Donald Boulter, opened new premises at Nos 11-13 Scot Lane under the name of Dennis Roberts & Co. This, however, was short lived and the name of Dennis Roberts, synonymous with drapery in the town for more than a century, faded away.

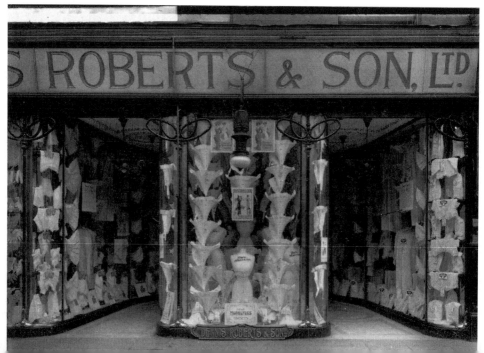

Dennis Roberts premises in St Sepulchre Gate.

The death of French Gate's bookseller
and stationer John Galloway Robinson on
Monday 6 June 1898 caused quite a stir in
the town. On leaving the shop about
10 a.m. he told an assistant he would
be back a little later for a business
appointment. Shortly afterwards, he
appears to have forgotten about the
appointment and hired a boat. He left his
coat and waistcoat in the boat house and it
was about three-quarters of an hour before
he was found dead in the water. Later,
an inquest recorded an accidental death.
Robinson was the son of Reuben Robinson,
who ran a book-binding business in French
Gate. After the death of John's father, his
mother added book selling and stationery
to the business, which, on the completion
of his apprenticeship at the *Gazette* offices,
John helped her run. His mother died
around 1871, and then he took control of
the business. He married Miss Rust, from
Wisbech, by whom he had twelve children,
eleven of whom were living at the time of
his death at the age of fifty-two.

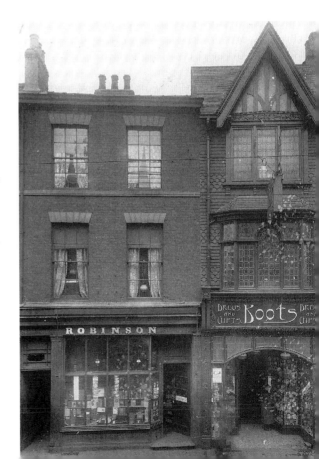

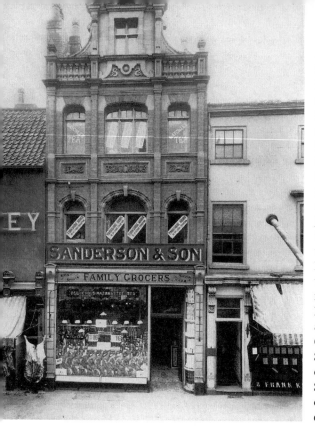

Alfred Sanderson was the son of a London hotel proprietor. He came to Doncaster at the age of eleven, shortly after his father's death and was cared for by his aunt. During 1857 he became an apprentice in a Leeds' grocery business, but returned to Doncaster three years later to become an assistant to Thomas Parkinson in his shop at the corner of St Sepulchre Gate and Printing Office Street. After Parkinson retired in 1873 Sanderson, together with Joseph Stringer and John West, bought the shop and their business expanded to various premises around Doncaster. In 1907 Stringer and West relinquished their partnership in the business, being replaced by Theo Sanderson, Alfred's son. During 1912 the business expanded again and the firm occupied No. 8 St Sepulchre Gate. By the early 1920s however, Sanderson & Son were operating from only one shop and, shortly after Alfred Sanderson's death in 1924, the business ceased to trade. These two photographs date from around 1900.

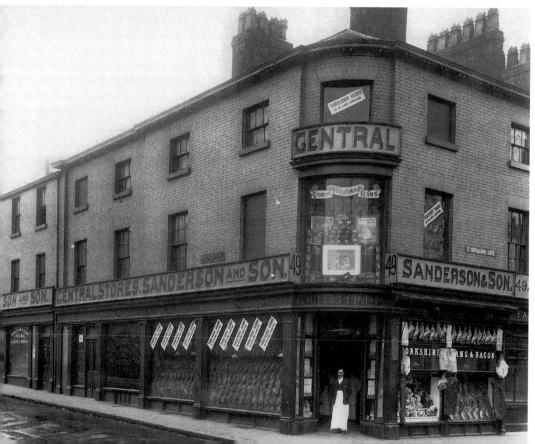

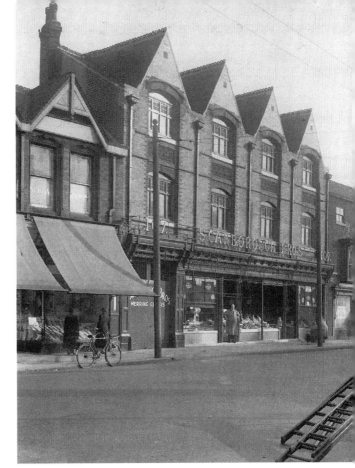

James Scarborough, fishmonger and greengrocer, began his St Sepulchre Gate business during the late 1850s. Following James Scarborough's death, the firm was continued by his nephew, Curtis Scarborough, who took into partnership one of the employees and operated under the name of Scarborough & Stacey. In 1890 Curtis Scarborough retired and was succeeded by Preston Scarborough. A year later the business was noted as Scarborough Bros, and in 1897 the St Sepulchre Gate premises were rebuilt. Interestingly, the *Doncaster Review* of March 1897 noted that Mr Preston Scarborough had opened 'his new premises in St Sepulchre Gate and has introduced the electric light for illuminating purposes being in fact, the first private tradesman to do so in Doncaster...' James Scarborough was a founder member of the Doncaster Motor Cycle Club and a keen angler.

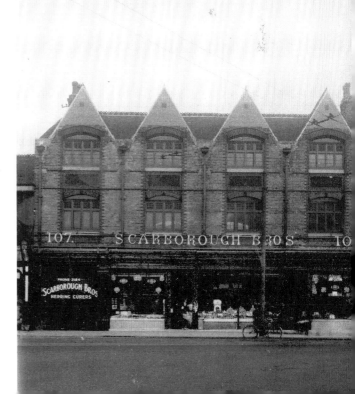

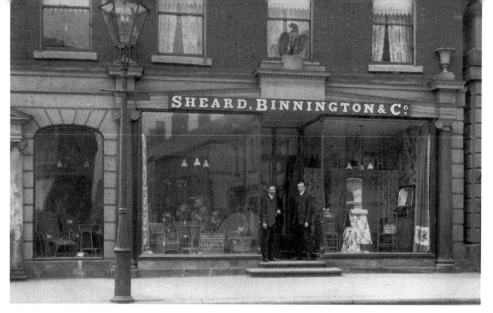

Above: The business premises of Sheard, Binnington & Co in Doncaster High Street. During January 1917 it was revealed that Second Lieutenant Arthur William Sheard, a partner in the firm, had been killed in action. The business had been established by his father George Sheard and Henry Binnington jnr in 1885. His father died in 1904 and five years later at the age of twenty-two, Arthur became a partner in the family firm. It was stated that he did not come without fresh and up-to-date ideas, and these were absorbed by the firm, and gave a fillip to its enterprises. At the start of the war Arthur joined the Public Schools Battalion of the Royal Fusiliers and spent the winter of 1915-16 in France in the ranks before gaining a commission. He died in hospital on 17 January 1917. Sheard, Binnington & Co. lasted until 1953. Subsequent tenants of the building have included Harrison Gibson Ltd, Eyres Ltd and Britannia Ltd.

The 1875 Public Health Act compelled many local authorities to attain a number of wide-ranging health standards, including a minimum width for streets. This encouraged Doncaster Corporation to embark on a street-widening programme. This photograph shows commercial property on the northern side of Silver Street, which was demolished during the widening scheme.

Opposite below: Scarborough Bros continued until the 1960s when the premises were required for road improvements and the company ceased to trade. Bagshaw took several photographs of the new Scarborough Bros premises, as can be seen here and on the previous page.

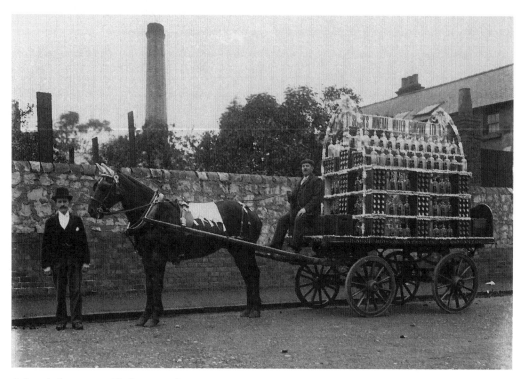

A dray belonging to Slacks Co. Ltd's Mineral Water Works, Balby, near Doncaster.

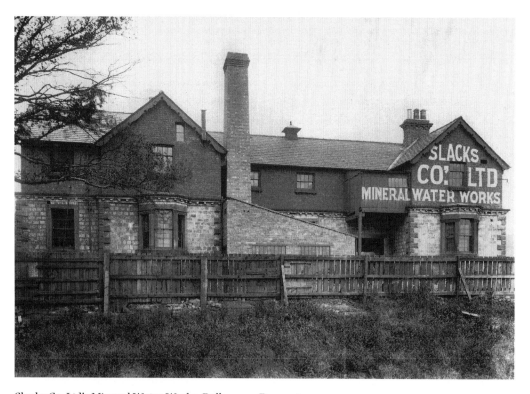

Slacks Co. Ltd's Mineral Water Works, Balby, near Doncaster.

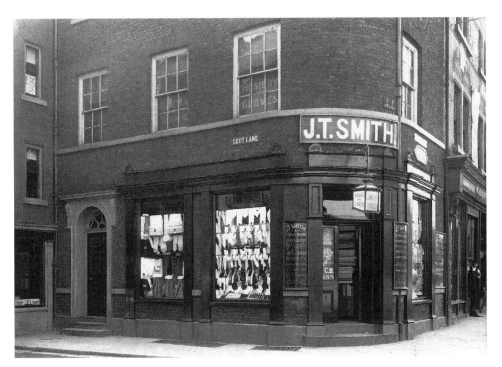

John Taylor Smith's business premises at the Scot Lane and Market Place corner. A sign on the side of the building announces that he was a general draper, hosier and glover. He was a native of Worksop and came to Doncaster to open the Market Place business around 1887. It was said that he built up a sound business by his perseverance and attention to detail. He died aged seventy-four in 1924. Bagshaw took this picture before the premises were taken in the Scot Lane widening scheme.

G.J. Smithson had been a gunsmith in Scot Lane for thirty-seven years when he died aged seventy in the early part of 1918. And it was said no man was better known in the thoroughfare. Indeed, he was the doyen of the tradesmen, and he was often referred to as the 'King of Scot Lane.' The circumstances under which Smithson came to Doncaster recall a tragic incident in local history. He was a native of York and learned the business of a gunsmith with Horsley & Son of that city in April 1864. During January 1880, the gunsmith's shop of George Hanson, in Baxter Gate, was blown out by a terrific gunpowder explosion, which killed Mr and Mrs Hanson and their next door neighbour, Miss Roberts. Smithson's firm at York took this opportunity of coming to Doncaster and opening a branch establishment and they sent Smithson there as manager. This was at No.6 Scot Lane. He remained with them twenty-five years and then started on his own account at No. 10 Scot Lane. In 1899 he purchased his old firm's business and went back to No.6.

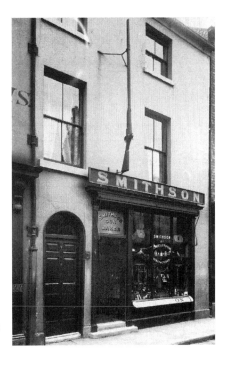

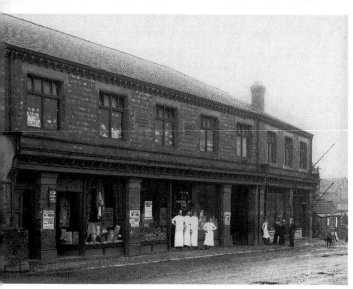

The Doncaster Mutual Co-operative Industrial Society's premises at South Elmsall.

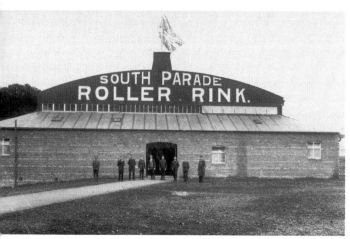

The roller rink behind South Parade which was opened on Monday 15 August 1909. The work – the outcome of local enterprise – was completed rapidly, giving skaters of Doncaster a large and handsome hall devoted to what was then a new cult. The rink was a red-brick building, with a girded roof about 30ft high and provided 14,000ft of skating area. Skaters had a clear run down the rink's sides of nearly 70yds, which compared favourably with the very best rinks. There was a 10ft promenade all round the skating area, separate cloak and skate rooms for male and females, and a band in a gallery and refreshment buffet on the ground floor.

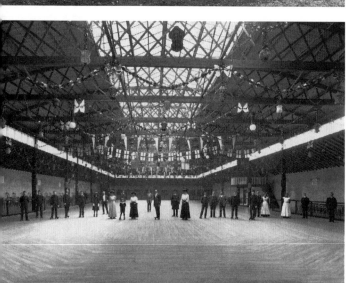

An interior view of the South Parade Roller Rink.

An interior view of the South Parade Roller Rink.

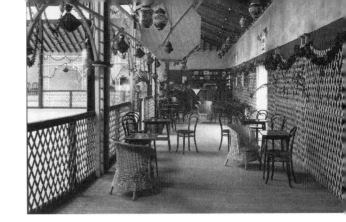

Stretch of commercial properties within Scarborough Buildings on St Sepulchre Gate. West Street is on the left.

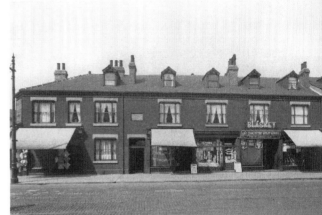

One of the most interesting buildings in Doncaster – the Subscription Betting Rooms – was occupied by furnishers Stamp Bros from 1895. The firm developed one of the most flourishing furnishing businesses in the district, made all their own goods and had large factory stores and timber shed in French Gate. Among the firm's productions were oak bedroom suites and sideboards, and 'they made a special feature of the new art wood bed-steads, the carvings on some of these being particularly fine.' Away from business, Bert Stamp was a keen motorcyclist, and nothing delighted him more, than a good long tour. Alf Stamp always protested that that he was too busy a man to have much to do with hobbies, but he was an enthusiastic sea angler, and a member of the British Sea Anglers' Society. By 1919 Stamp Bros premises had become a picture house, eventually known as the Savoy.

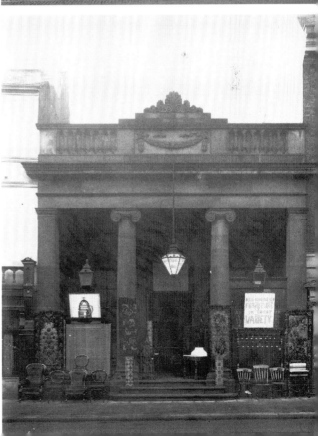

Left: Albert Henry Stamp, provision merchant, Nether Hall Road, died in his seventy-fifth year, in February 1917. He was a native of South Kelsey, Lincolnshire, and came to Doncaster from Hull in 1871. He commenced business in the provision trade with a market stand on the cobbles near the old theatre. He moved to Catherine Street, Wood Street, and then to premises behind the Doncaster Clothing Co.'s shop in Baxter Gate. He took the shop in Nether Hall Road in October 1882. Mrs Stamp had predeceased Albert and there were four sons: one in business in Nether Hall, one in business in High Street, one in HM Forces, and one in New Zealand.

Below: Photographing tradesmen with their horses and carts was a steady source of income for Bagshaw during his early professional years. The person in the photograph cannot be identified, but the location is recognisable as the corner of St James' Street and Cemetery Road, a site occupied by the Star Hotel. A date on the cricket poster displayed in one of the hotel's windows suggests the photograph was taken in July 1893.

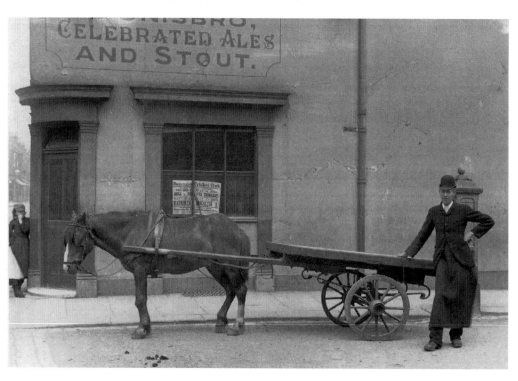

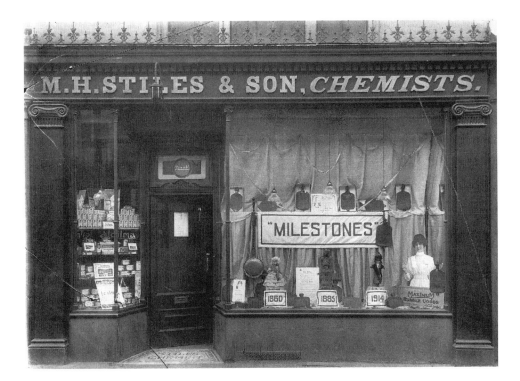

M.H. STILES & SON, CHEMISTS.

"MILESTONES"

1860 1885 1914

Above: The Stiles chemist shop, located at No. 2 French Gate, was an old established business, having been founded in the 1820s. However, by the 1930s five other chemist's had been opened in Doncaster, and Stiles' business was struggling. By 1932 it was in dire financial trouble and in April of that year the present owner Matthew William Stiles was declared bankrupt.

Right: High Street premises of fish and game dealer T.H. Swaby. Adjacent, left, is the Ram Hotel. Lincolnshire-born Samuel Plumpton Swaby was the founder of the business and moved to No. 38 High Street from Scot Lane, around 1837. He retired in 1876 and his son Thomas took control, remaining at No. 38 High Street until around 1913. Four other fish, game and poultry shops in Doncaster also carried the Swaby name.

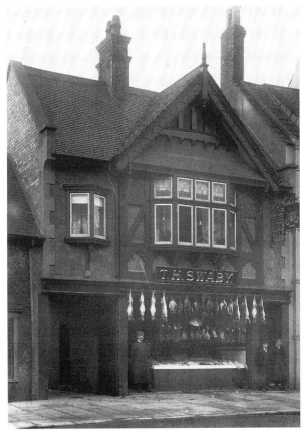

On 20 August 1936 seventy-seven-year-old F.W. Strawson, a leading Doncaster draper, retired after fifty-six years in the trade. A native of Lincolnshire, Strawson came to Doncaster around 1880 to work in the drapery firm of E. Penistone & Co. in the Market Place. In 1906 he left to set up a business of his own and two years later moved to a shop under the Sunny Bar clock. He became well-known as a carpet dealer. Strawson said that he had seen Doncaster undergo many changes some of which he believed were not for the better. There was not, he said, the same 'family feeling' between the customer and the shopkeeper that there used to be.

Well known in connection with timber and joinery requirements was the firm of John S. Trethewey in Fishergate. The firm's Fisher Gate Mills became the headquarters for all builders' timbers, floorings, mouldings etc, as well as the well-known Gyproc fireproof wall-board and ceiling-board, for which they were sole distributors for Doncaster and district. A very active side of the firm's output was the joinery department; here high-class joinery was made to customers and architect's specifications. Modern equipment, combined with a practical staff of specialist operatives, combined to produce products which had earned the business a high reputation.

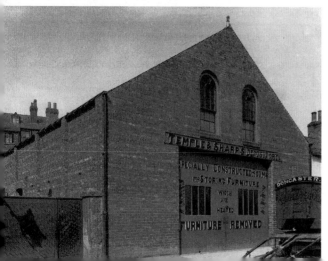

The location of this photograph is unclear; however it might be Low Road, Balby. Signage on the building announces that the company provided 'specially constructed rooms for storing furniture which are heated' and 'furniture removed by road, rail or sea.'

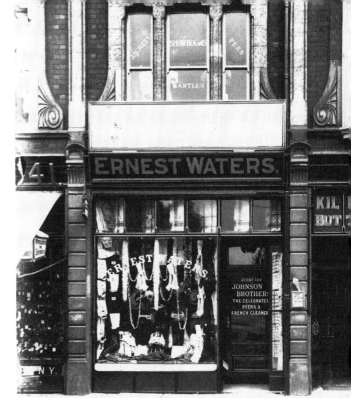

Ernest Waters' premises at No. 43
Jubilee Buildings, St Sepulchre Gate,
which he occupied from 1899.
By the late 1920s his premises had
been acquired by the ladies-outfitting
business of Edward Smith & Sons.

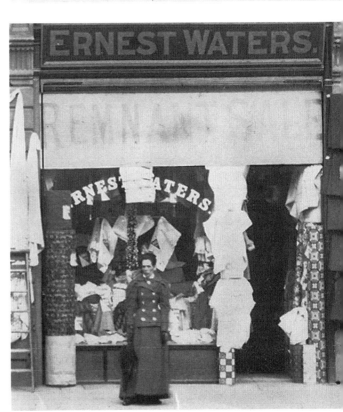

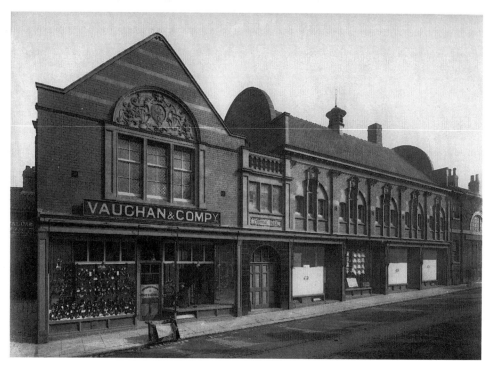

Above: Vaughan & Co.'s shop and the Central Hall, Printing Office Street.

Below: G. Watson's gentleman's outfitters shop at No. 19 High Street, Doncaster.

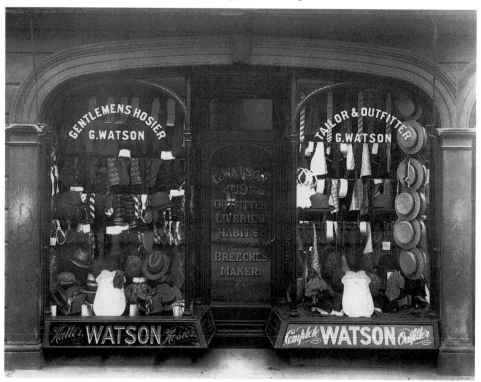

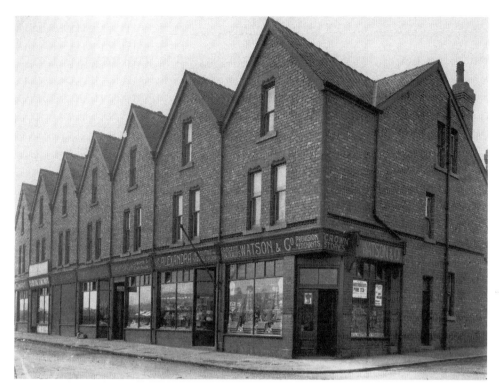

Above and below: Two views of grocers, provision merchants and tea dealers Watson & Co.'s shop at Denaby, near Doncaster.

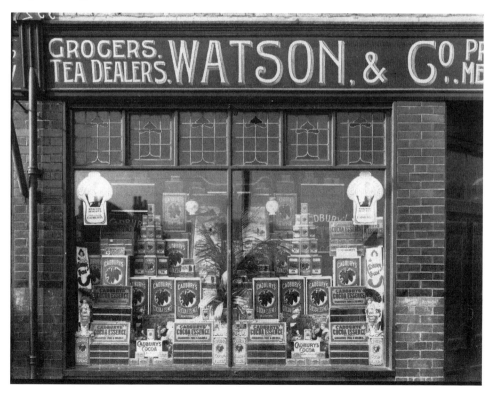

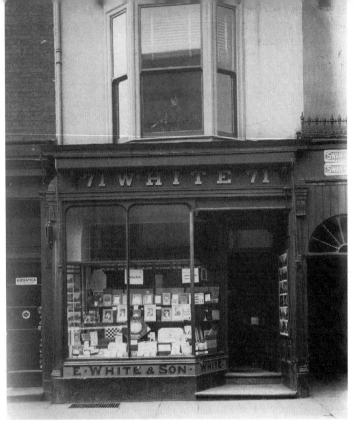

Edwin White was born in Baxter Gate in 1824, the eldest son of Charles White, stationer. On the death of his father he succeeded to the business. Subsequently, the firm's premises were sold and he moved to French Gate. It was said he was of a very affable temperament and exceedingly popular, but never held any public office. His attention, outside his business, was chiefly devoted to the parish church, where he was twice vicar's warden. He had one son, Herbert, who died suddenly in 1907. Shortly after that, E. White sold the French Gate premises to Boots Ltd, and took up residence in Waterdale. For some years prior to his death in May 1909 he was the oldest Freeman of the Borough of Doncaster.

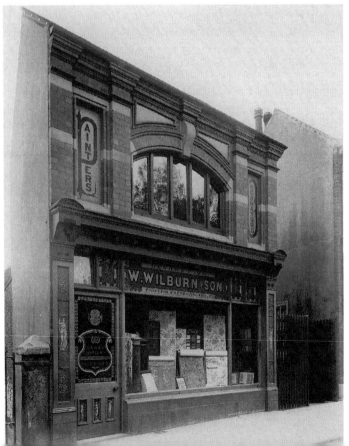

W. Wilburn & Son, painters and decorators, Wood Street. Walter Wilburn was one of Doncaster's oldest tradesmen when he was laid to rest at the Green Dyke Lane Cemetery on Friday 25 June 1920; he was eighty-three. It was said that he was not an active participator in public affairs, but was a quiet and energetic worker with a wide circle of friends and acquaintances and had been president of the local branch of the Doncaster Master Painters Association.

George Wilton's Victoria Yorkshire Mustard Mills occupied a large area of ground on the south bank of the canal at Marsh Gate. George, born in 1831, had begun the business in the Market Place at the age of twenty-two and transferred it to Marsh Gate in 1867. Large quantities of the company's products were sent all over the world. George Wilton died in 1911 and five months later the company went into voluntary liquidation.

George Wilton's move to Marsh Gate in 1867 was noted by local author William Sheardown: 'Mr George Wilton has erected on the south bank of the New Cut very extensive works for manufacturing various articles. The buildings are from plans by Mr Booth, of Rotherham, and were executed by Mr Salmon, under Mr Wilton's superintendence. Mr Wilton has also erected on the ground two dwelling houses facing the Cheswold, one for his own residence ... The machinery, to carry on the various trades, is of the latest improvement, and can turn out weekly above a ton of mustard, fully prepared for the table.'

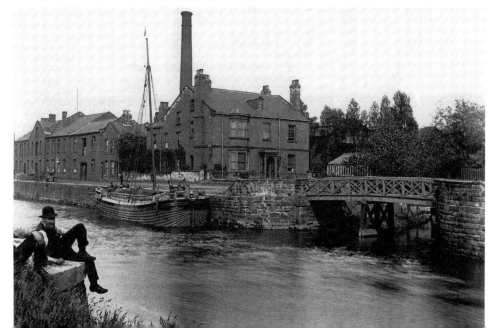

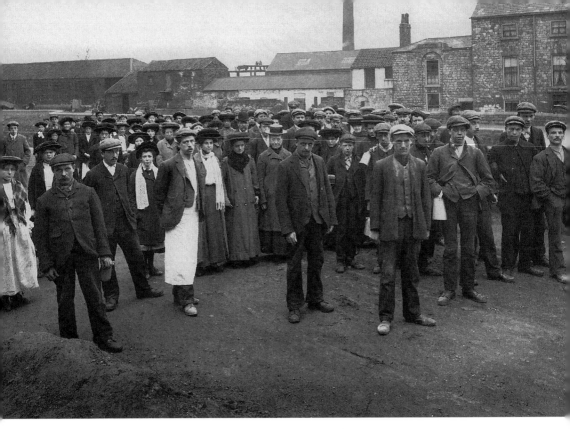

An idea of the size of George Wilton's operation, shortly after the move to new premises, is given by the 1871 census. It reveals that he was employing ten men, nine boys and twenty-six girls. An advertisement placed in the *Doncaster Gazette* of June 30 1871 shows that his business had diversified: 'George Wilton begs to call the attention of the public (both town and country) to his stock and great variety of coals for household and engine purposes, which having free and immediate communication with the Canal and the entire Barnsley collieries, and employing his own boat for their conveyance, he is able to offer at such prices as to fey competition.' A list of 'coals' available were then listed and priced, and included Wilton's 'Victorias.'

Opposite above: George Wilton probably chose the site for his new factory not only because it was adjacent to the canal, but for its close proximity to the extensive rail network, of which Doncaster had become an important part. Also around this time, there was talk of constructing a ship canal, which would enable 200-ton boats to navigate as far inland as Sheffield. George would have gained enormous benefit from this because Sheardown also mentioned: 'Mr Wilton has an extensive trade in England, and large quantities have been sent into Canada, Peking, Bombay, New York and Germany.' Alas, however, the projected ship canal never came to fruition.

Opposite below: Success continued for George Wilton during the 1880s and on 24 January 1887 the company was incorporated, becoming George Wilton, Son & Co. Ltd. One of the conditions of the sale of the business to the company, by George Wilton, was that he should remain as managing director for life at a salary of £500 per annum.

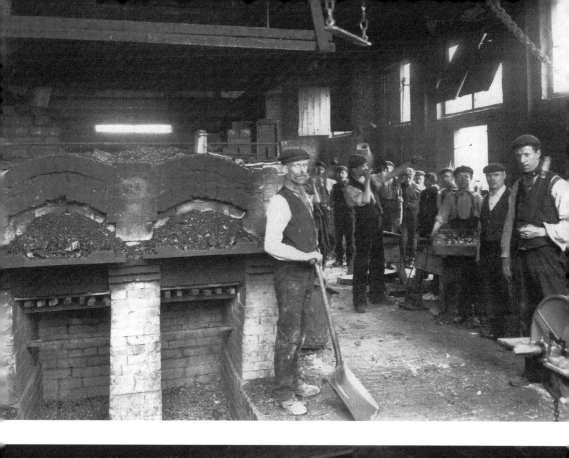

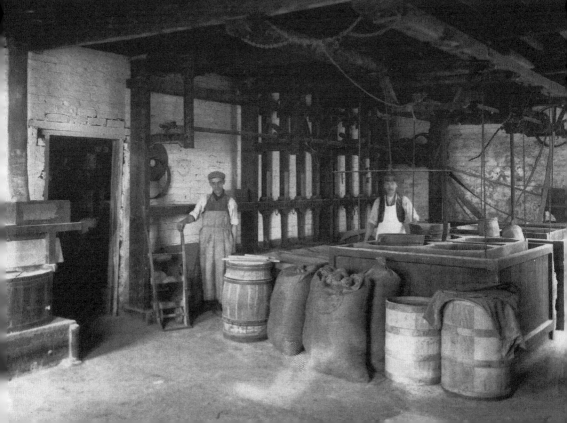

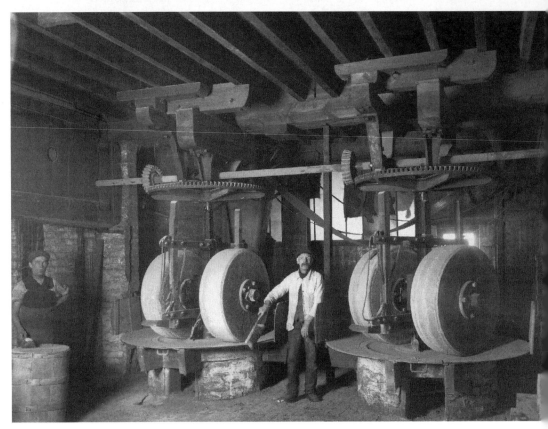

The *Doncaster Gazette* of 30 March 1888 reported on the first annual general meeting of George Wilton's shareholders: 'An increase in the sales of nearly 15 per cent over the previous year ... additional works, consisting of new saw mill, box factory, sauce and ketchup factory, and bottling room, had been erected, and a glass house for making the whole of the smaller sized bottles used by the company ... The bottle-making works (which we believe are the first to be built in Doncaster) are within a very short distance of the main buildings ... many of the goods, the bottles to pack them in, and the boxes to pack them for shipping away, are all made within a few yards of one another, and packed up on the spot, thus ensuring freshness to the buyer.'

Opposite above: Wilton's additional new works made the company a self-contained manufacturing unit with four distinct businesses being carried out: confectionary, grinding and packing, wooden box manufacture, and glass bottle blowing. Additionally, up to 150 hands were employed. Whilst Wilton's company grew and prospered during the latter half of the nineteenth century, it was short lived during the following one. George Wilton resigned in 1910, and died a year later aged eighty.

Opposite below: Only five months after George Wilton's death the *Doncaster Chronicle* of 17 May 1912 reported that George Wilton, Son & Co. Ltd had gone into voluntary liquidation. George's son G. E. Wilton put part of the blame on 'the national Railway Strike and then ... a National Coal Strike, which incidentally entirely closed the most profitable part of the company's works for about seven weeks.' The buildings were purchased by the Great Northern Railway Co.

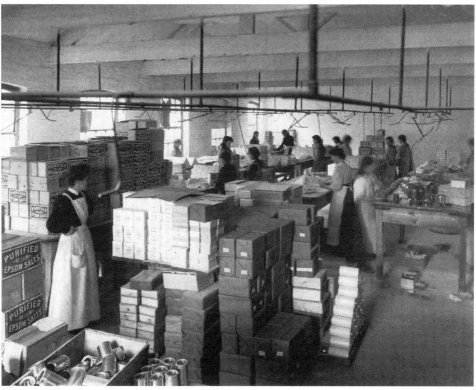

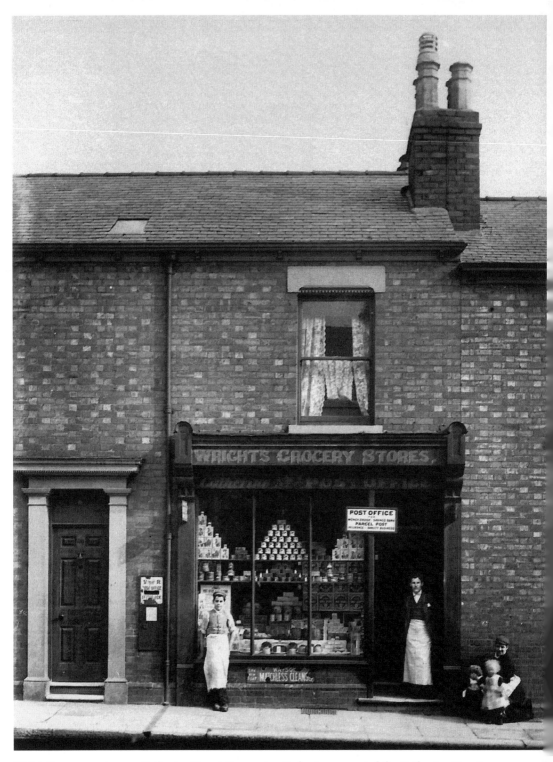

Wright's grocery store on Catherine Street, Doncaster. It also incorporated the Catherine Street post office.

2

CONISBROUGH VIADUCT

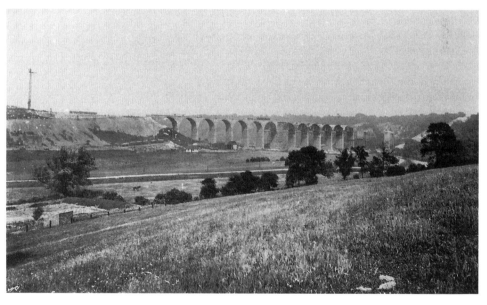

Conisbrough viaduct was built in around 1906 by the Dearne Valley Railway Co. The line was intended to connect the Lancashire & Yorkshire Railway, near Wakefield, with the Great Northern and Great Eastern Railways at Black Carr just below Balby. It was the most distinguishing engineering feature of No. 4 section of the new railway, the final portion of the line from Conisbrough Cliff to Cadeby. The centre is 115ft above the River Don. It consists of twenty-one arches, fourteen on the western or Cadeby bank of the river, and seven on the eastern or Conisbrough bank, which are connected by an iron girder bridge. The contractors for this section of the new line were Messrs Henry Lovat Ltd of London and Manchester and the work was carried out under the supervision of R.H. Clayton of Doncaster, the engineer of the Lancashire & Yorkshire Railway. Mr Kaye of Leeds was the designer of the viaduct, and John Steel was the clerk of works in charge, on behalf of Messrs Lovat. John Steel was widely experienced in large engineering contracts, but regarded Conisbrough viaduct as the largest thing he had seen in the way of railway bridge building.

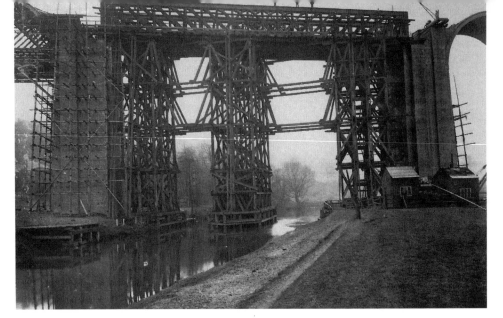

Each one of the arches within the Conisbrough viaduct has a span of 55ft, varying in height from 40ft at the eastern and western extremities, to 115ft in the centre. The girder bridge seen here across the river has a span of 150ft. The total length of the viaduct is 528yds, or a quarter of a mile and 88yds. The viaduct arches were built of red brick, faced with a double course of Staffordshire pressed blue brick. The last official passenger train across the route was in 1951.

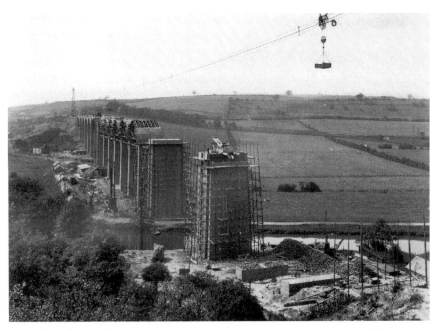

A feature of the work on the Conisbrough viaduct was the overhead travelling cradle, which was used for carrying men and materials to-and-fro across the river. It was technically called a 'Blondin' and was an American invention, first employed in England in connection with the erection of Vauxhall Bridge across the River Thames.

3

CORPORATION WORK

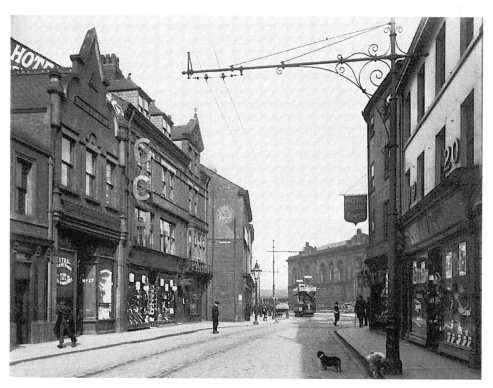

Baxter Gate in 1904. The left-hand side of this picture illustrates how far the street line had been set back following the widening scheme in 1894. David Lessing, wholesale and retail pork butcher, occupied the tall, gabled building on the extreme left of the photograph (No. 17 Baxter Gate). Fire damage in June 1893 quickened the Corporation's plans for rebuilding and setting back his premises. The adjacent property formerly owned by Parkin & Son has since been demolished and the site is now occupied by Littlewoods' Department Store.

Balby Bridge looking towards the junction of St Sepulchre Gate and St Swithin's Terrace. Luke Bagshaw took this picture to show the telegraph wires stretching over the Bridge. Much of the property depicted, built during the late nineteenth century, was cleared as a result of several compulsory Purchase Orders during the 1960s. The Balby Bridge fly-over, constructed during the mid-1970s, now covers much of the site.

Balby Council Offices are seen on the left from Low Road; Ashfield Road and Tickhill Road are in the distance.

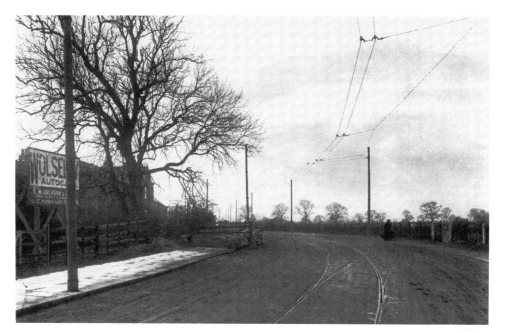

The view is at Balby looking north-west on what is now called Fairway Hill, a pub of that name now occupies a position on the left. Luke took the picture to show that during the early part of the twentieth century the Balby tramway route's extension from Oswin Avenue to Warmsworth followed little more than a country lane. The route, however, in the ensuing years was to see a large amount of suburban expansion. The 'passing loop' near (what later became) Anelay Road Balby can be seen in the foreground.

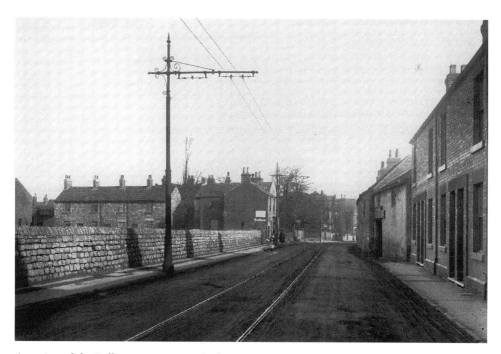

A section of the Balby tramway route looking eastwards from near the Oswin Avenue terminus along High Road towards Doncaster.

Left: The Corporation commissioned this picture in 1904 to illustrate the widened Baxter Gate Street. Beetham's new building can be seen in the distance together with other properties incorporated in the scheme. One of the reasons for widening the street was to accommodate a tramway route, constructed in 1903 and used by the Beckett Road and Avenue Road Services.

Below: Wine and spirit merchant Joshua Beetham was the only person, in October 1893, objecting to the Corporation's plans for widening Baxter Gate. It was intended to take some land occupied by his Dutch-gabled premises at the corner of St George Gate and Baxter Gate and construct, by way of compensation, a three storey building on approximately the same site. Beetham stated that he did not require premises of this type and towards the end of the year the Corporation amended their plans, constructing a two storey building instead. These new premises, sometimes known as the George and Dragon Vaults existed until 1961 when they were reconstructed again. This photograph was taken during 1894 and illustrates the Dutch-gabled premises prior to demolition.

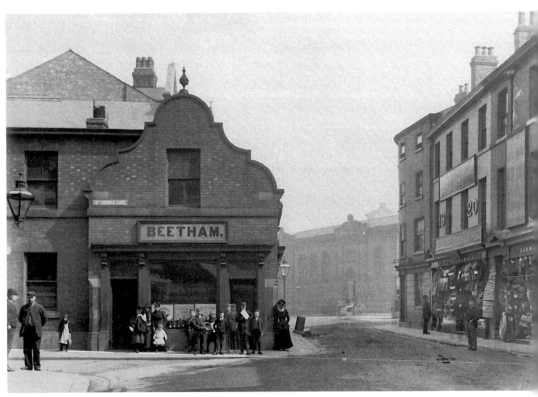

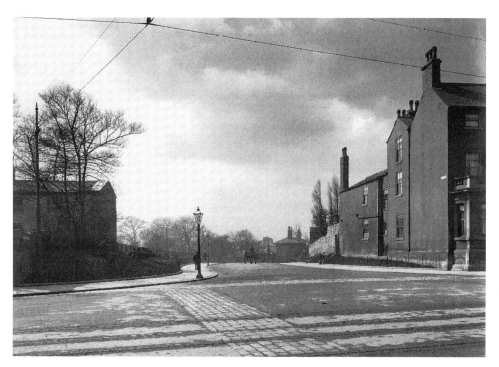

Branson Street from the Hall Gate and South Parade junction looking west towards Waterdale.

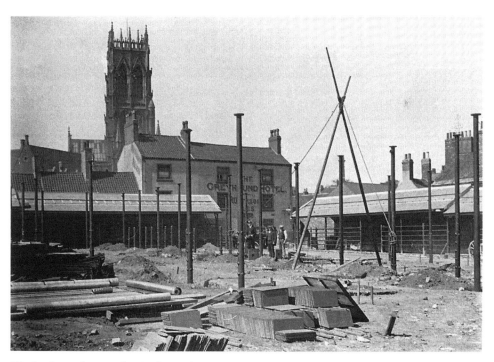

Work taking place on the Cattle Market extensions in 1908; the view is looking towards
the Greyhound Hotel (now demolished) and St George's Church. Within the new area, an
octagonal auction ring was built. An avenue of trees was also planted on the main driveway in
the Cattle Market.

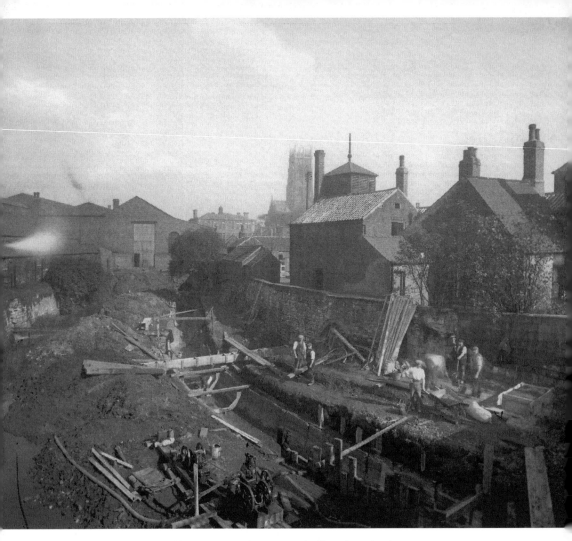

Culverting the River Cheswold, *c.* 1920, with St George's Church in the distance.

Opposite above: Cheswold culvert with North Bridge in the background, *c.* 1920.

Opposite below: Cheswold culvert with North Bridge in the background, *c.* 1920.

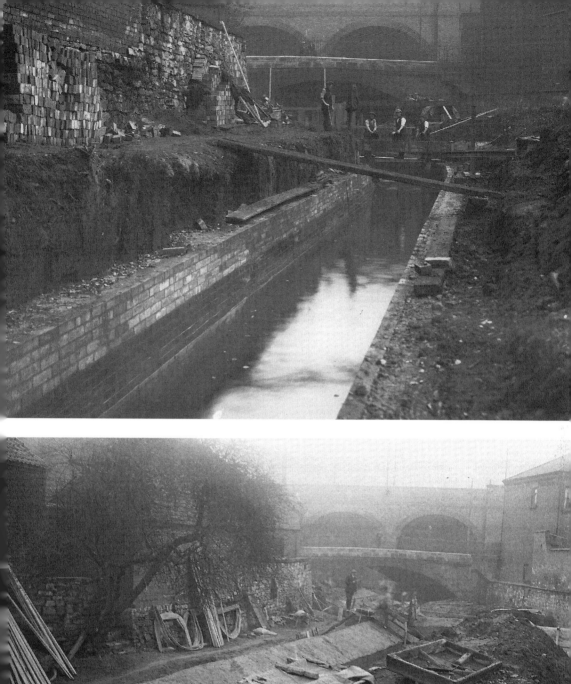
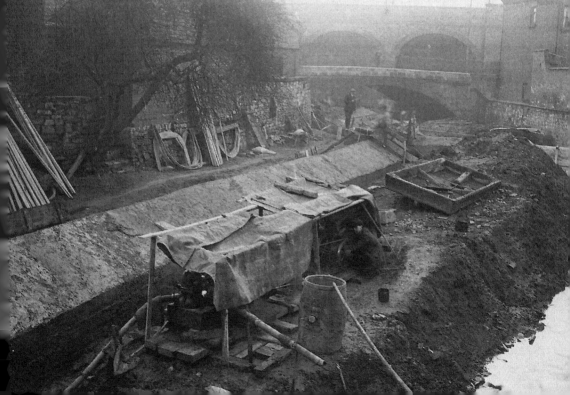

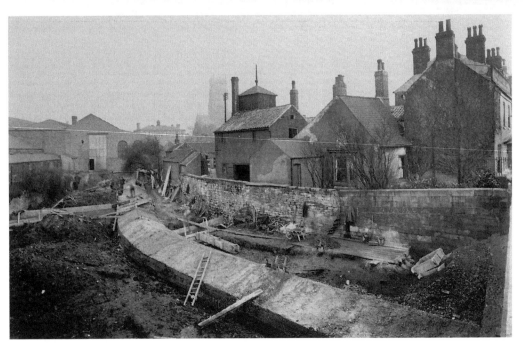

Cheswold culvert, with St George's Church in the distance, *c.* 1920.

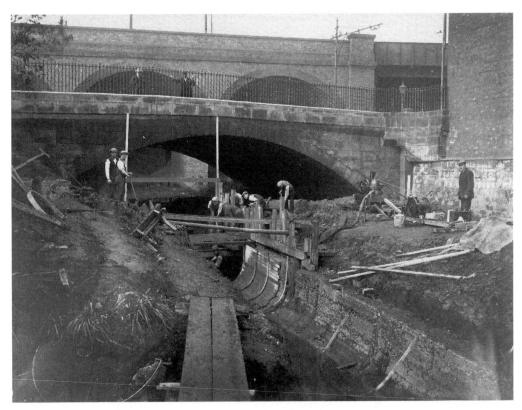

Cheswold culvert, with North Bridge in the background, *c.* 1920.

Church Lane, extending between French Gate and St George's Church; the Barrel Inn is on the left and St George's Church is peeping through in the distance.

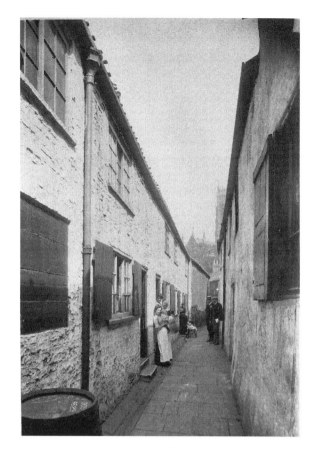

Cleveland Street, showing the Doncaster Intercepting Sewer, shaft 16 headgear. The picture dates from 11 December 1922. King Charles' Terrace, erected in 1842, can be seen in the background.

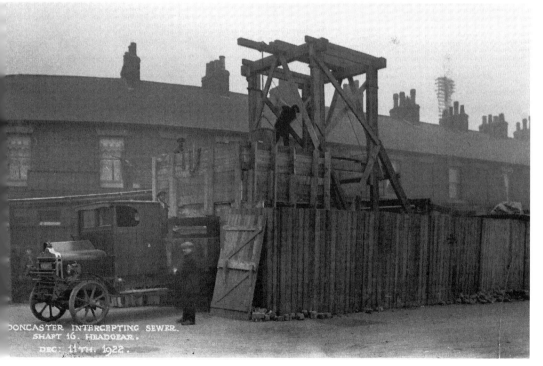

DONCASTER INTERCEPTING SEWER.
SHAFT 16. HEADGEAR.
DEC: 11TH. 1922.

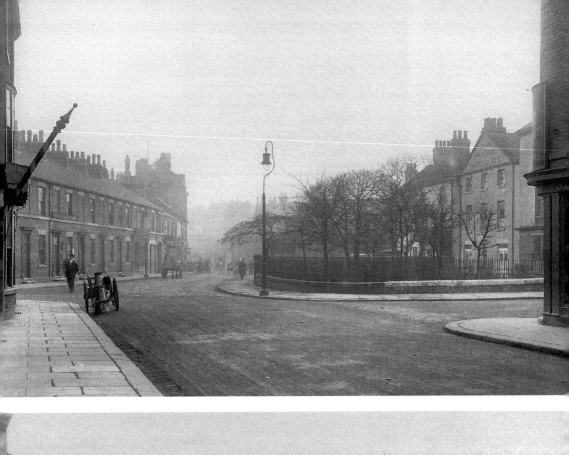

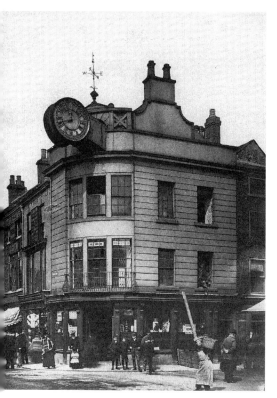 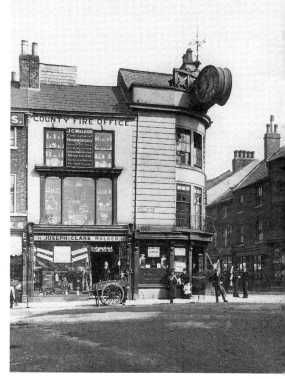

The widening of Baxter Gate during the early 1890s included the demolition of a site at the junction of French Gate and Baxter Gate, commonly known as 'Clock Corner'. The clock was affixed in 1838 and had been one of Doncaster's most prominent landmarks. During 1895 new, more elegant premises housing a clock tower were constructed to the designs of architect of J.G. Walker. The reconstruction of 'Clock Corner' was one of the first major municipal events that Luke Bagshaw photographed during his early career. Whether or not the photographs were commissioned by Doncaster Corporation is uncertain. Two photographs were taken of the old premises being demolished, and another of the new premises following completion. The latter was also used for a picture post card, printed and published by R.H. Hepworth.

Opposite above: Cleveland Street with Young Street on the right and Silver Street in the distance, *c.* 1915.

Opposite below: Cleveland Street from the Wood Street junction with Silver Street in the distance and the Ram Hotel on the left.

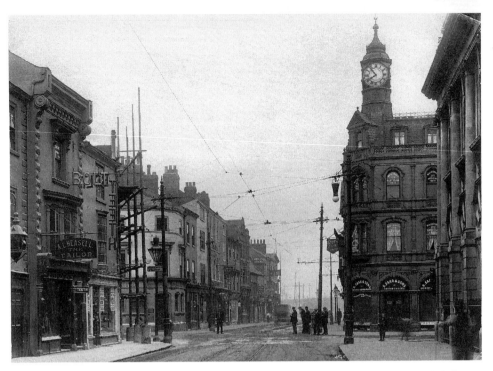

Above: The rebuilt Clock Corner on the right and French Gate ahead. Note also on the left the scaffolding, which indicates that work has started on the widening of St Sepulchre Gate with the demolition of the newsroom and library (out of view). The picture was taken in around 1910 and work on the St Sepulchre Gate widening continued through to the 1930s.

Below: The interior of the electricity station in Greyfriars Road.

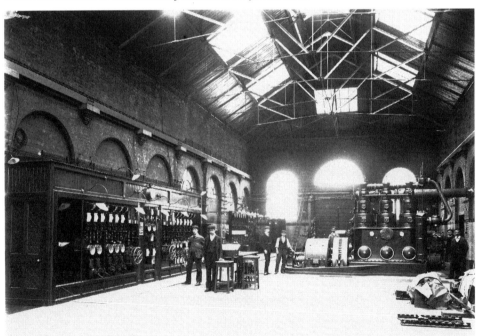

Two pictures taken to show East Laith Gate before it was widened. The one above shows the street from Nether Hall, the one below from the Silver Street junction.

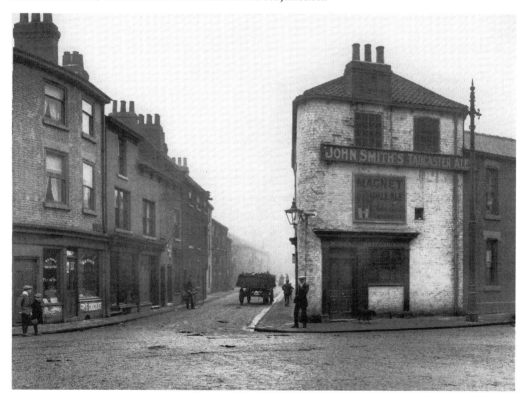

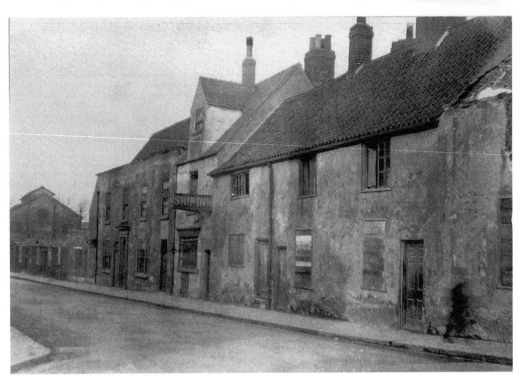

Above and below: Two views of the south side of Friendly Street before it was cleared for the cattle market extensions. Within the stretch of properties is the Ship Inn, dating from at least 1782.

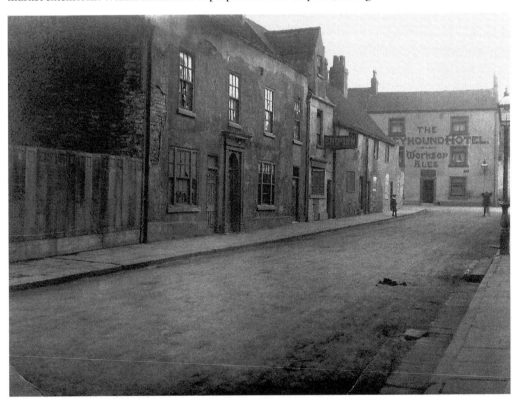

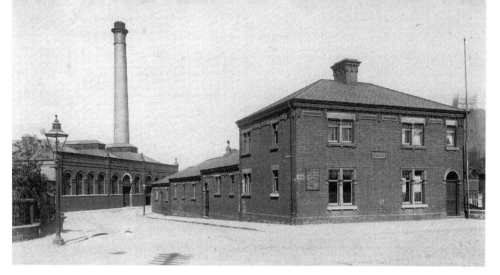

The electricity station (on the left) in Grey Friars Road supplied power to the street lights of Doncaster from the end of 1899. The first supply of electricity to the general public was switched on by the mayoress, Mrs Bentley, at midday on 2 April 1900. The Corporation's charge for electricity in 1901 was 5*d* per unit, but following the commencement of the tramway services the extra demand for electricity was so high that the Corporation was able to spread the overhead charges and reduce the price per unit to 3*d*. The electricity works, however, made a loss of £4,625 in 1902, though a short time afterwards the tramways purchased half the station's output over a number of years, which helped the electricity department to become a leading source of energy for the town. The Greyfriars Road electricity station continued to operate until the late 1950s when it was replaced by a new station at Crimpsall Ings.

Prior to 1902, cattle were moved from the cattle-docks, near the railway station, to the market via French Gate and Baxter Gate. However, with the introduction of tram services along these roads, in 1902, further congestion was avoided by the construction of Greyfriars Road as an alternative route. The Old Crown Hotel had to be set back to facilitate the construction of a section of Greyfriars Road and this photograph shows the road along with the new Crown Hotel, the photograph was commissioned by the Corporation, *c.* 1904.

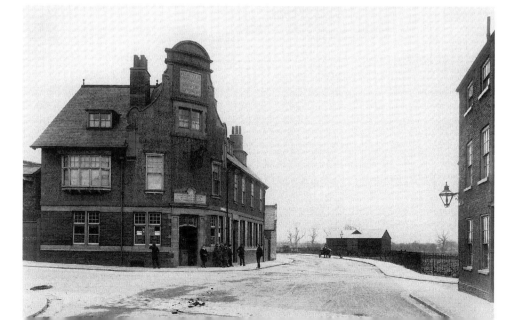

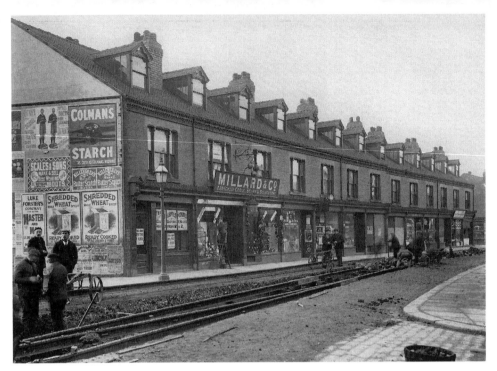

Labourers lowering a 'centre-grooved' rail into position to establish a 'passing loop' at the corner of Spansyke Street in Hexthorpe. Using simple tools and equipment they earned 5*d* to 5½*d* an hour. Although Doncaster and Hull were the only tramway systems to employ 'centre grooved' rails in the electric era, the Liverpool horse tramways and Dudley-Wolverhampton steam tramways had utilised a similar type of railing in the 1880s and 1890s.

Highfield Road, looking towards St Mary's Road.

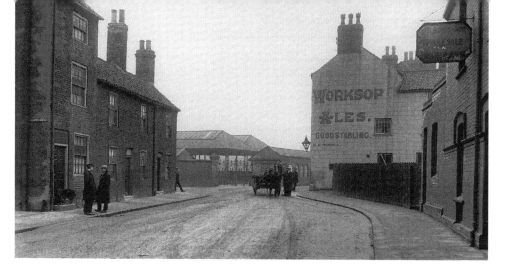

A view of High Fisher Gate, looking towards the cattle market. Following the construction
of Greyfriars Road, the Corporation had to widen the approach to the cattle market in High
Fisher Gate. This photograph of the area, taken for the Corporation around 1915, shows that
the improvements were achieved by setting back the properties on the right. The public house
advertising 'Worksop Ales' and 'Good Stabling' is the Greyhound Hotel.

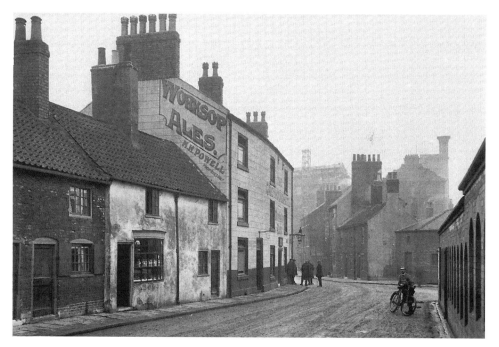

High Fisher Gate, looking towards Greyfriars Road, the Greyhound Hotel is on the left.
For extensions to the cattle market, completed in 1909, the Corporation acquired property in
both High Fisher Gate and Friendly Street for the work. The *Doncaster Gazette* of 15 October
1909 reported: 'The purchase of the property was additionally desirable in that it removed,
among other things, an unsanitary area which had already been condemned by the Public
Health Authority. Moreover, the acquisition of the property enabled the Corporation to widen
both the streets in question by setting back the frontage.'

Work taking place on the removal of the Horseshoe Pond during the 1920s. Carr House Road is on the right.

The Horseshoe Pond is on the right and Bawtry Road to the left.

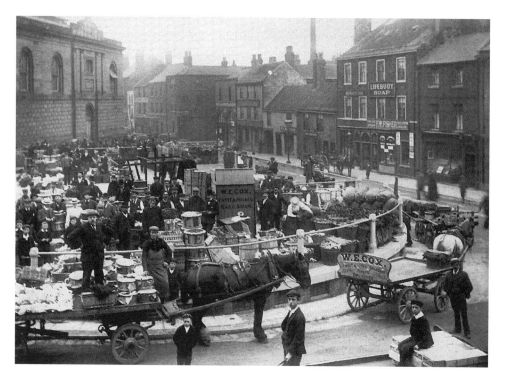

This picture of Market Place was taken after the theatre was demolished. It also shows how the site was redeveloped. The road leading around the Market Place has been widened, and a raised and enclosed area constructed for the use of market traders. Although showing Corporation improvements, this photograph was taken for wholesale greengrocer and fruiterer W.E. Cox, whose stalls can be seen in the foreground. The view is probably from an upstairs room in the 'Red Lion Hotel'.

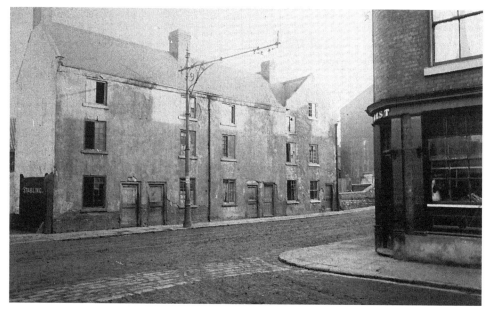

View of property in Marsh Gate before the construction of North Bridge.

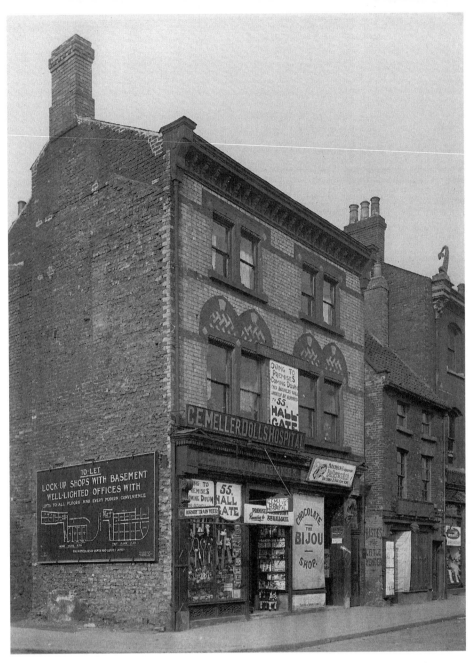

A sign on the front of Meller's Market Place shop reads: 'Owing to premises coming down this business will shortly be removed to No. 55 Hall Gate.' The diagram on the wall gives details of new premises, which were offered for sale or lease by T.H. Johnson. Meller's premises were taken to facilitate the widening of Scot Lane.

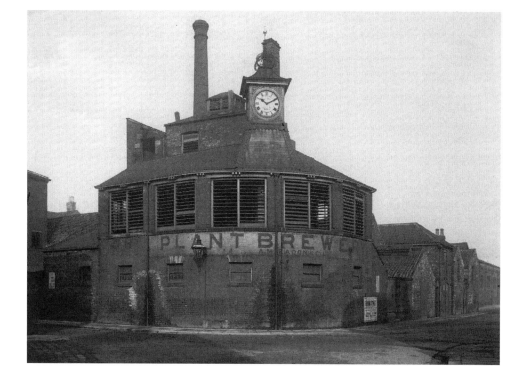

The Plant Brewery, owned by
Alfred Eadon & Co. Ltd, at the
Sunny Bar and Market Road
corner.

Portland Place, which extended
from St Sepulchre Gate.

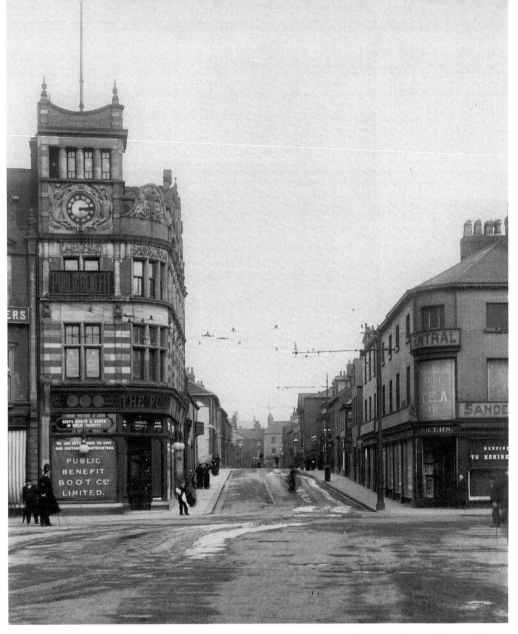

Printing Office Street from St Sepulchre Gate looking towards Cleveland Street. The Public Benefit Boot Co. Ltd's building on the left was erected around 1899. Before the work took place, Doncaster Corporation set back the street line. Luke Bagshaw took the picture to show the work had been completed. The *Doncaster Gazette* of 11 March 1898 reported the following: 'Since the Hyde Park district has become so important a residential quarter the traffic in Printing Office Street has been very great and the value of the street for business purposes has been very largely enhanced, therefore the Corporation could not allow the erection of a building at the very entrance of the street at this narrow part upon the whole of the site as purchased by the Public Benefit Boot Co. Mr Franklin, the managing director of the company, paid for the property £3,000, and for the setting back the Corporation gave him £1,250 ... The new building of the Boot Co. has a frontage of 17ft to St Sepulchre Gate, and 50ft to Printing Office Street.'

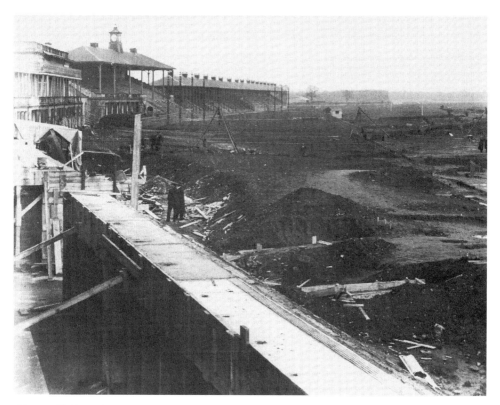

Above and below: The New Race Stand under construction.

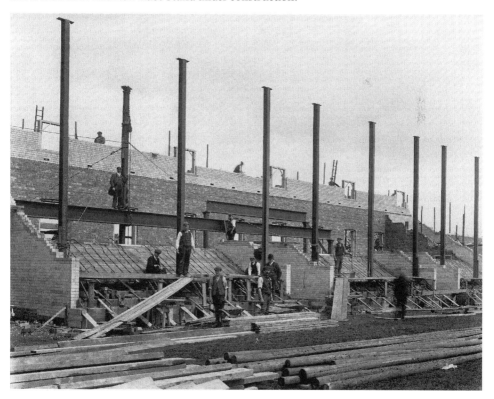

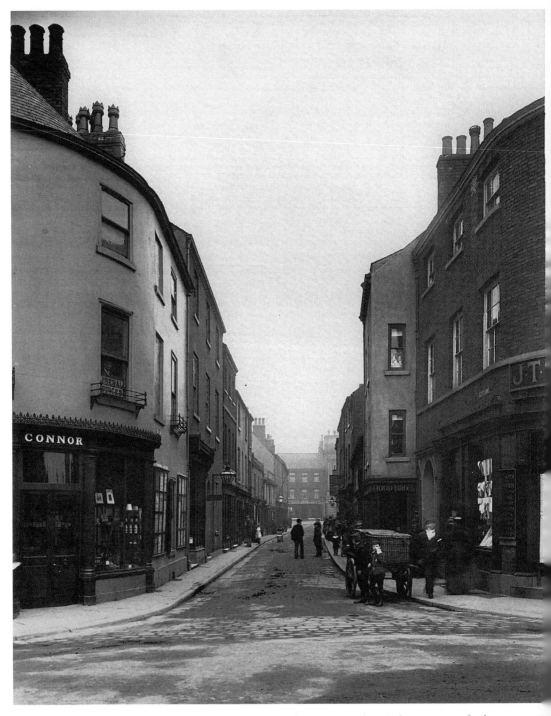

Scot Lane from the Market Place, looking towards Sheard, Binnington's & Co.'s premises, which may be seen in the distance.

A detail from the larger view of Scot Lane, seen opposite, looking towards High Street, taken before the thoroughfare's widening.

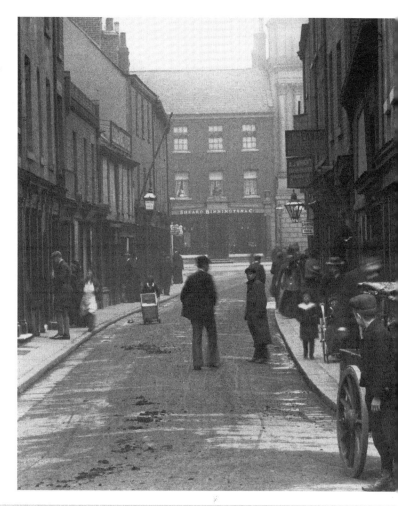

A view of the Race Stand.

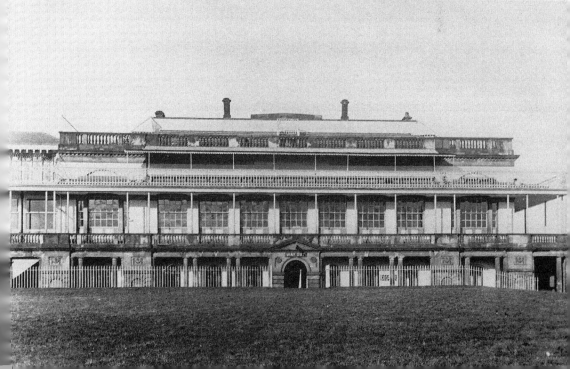

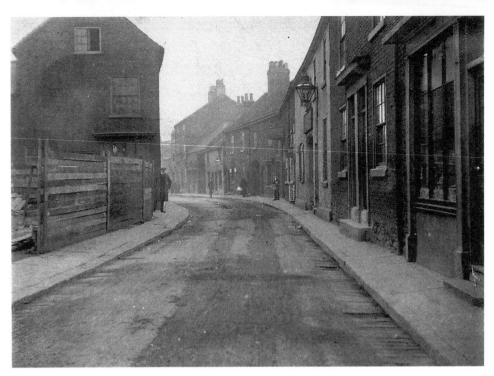

Silver Street before widening and looking towards Sunny Bar.

Rebuilding work on the northern side of Silver Street as part of the widening scheme. The work took place in 1908 and an idea of the narrowness of the street may be gleaned from the pictures on the opposite page.

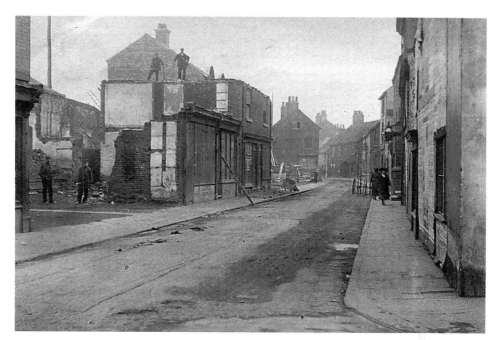

Work being undertaken on the widening of Silver Street. The view is looking towards Sunny Bar. For Silver Street's widening, Doncaster Corporation decided to set back the north side. The scheme disrupted many private occupants and businesses, mainly on the stretch from High Street to Bower's Fold as this was the street's narrowest section. This was also the area where the Corporation encountered most of the compensation problems.

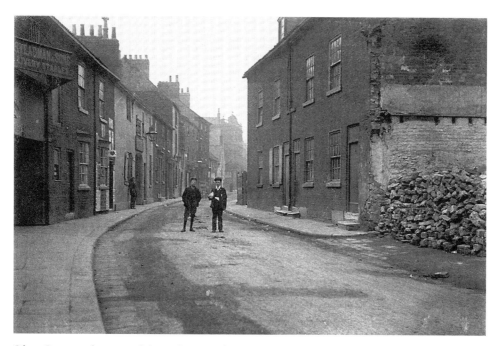

Silver Street at the start of the widening scheme. Note Steadman's premises on the left. The Corporation established a Street Improvement Sub-Committee, to deal with the various street widening schemes.

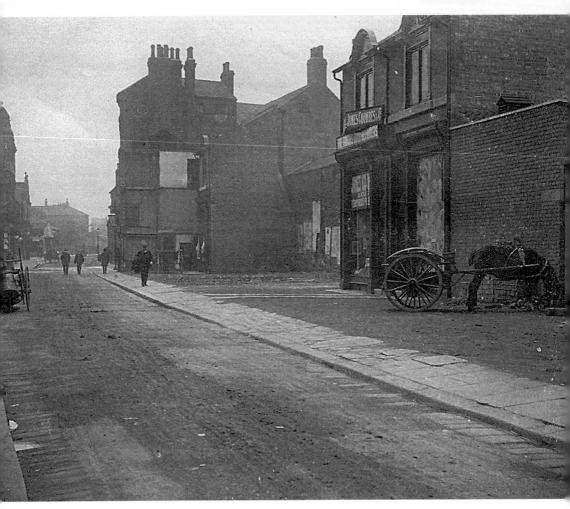

Silver Street, looking towards the High Street junction, the new building shows how far the street has been set back. Land at the rear of the Old George and Woolpack Hotels was also taken. The Corporation agreed to pay £7 per sq. yard, and cover the cost of pulling down and removing any buildings. During the alterations, a plan was prepared showing the surplus land and, on an area between High Street and Bower's Fold, the Corporation erected a number of shops, which were subsequently leased.

Opposite: A view of Silver Street before widening, looking towards the junction with Hall Gate and High Street.

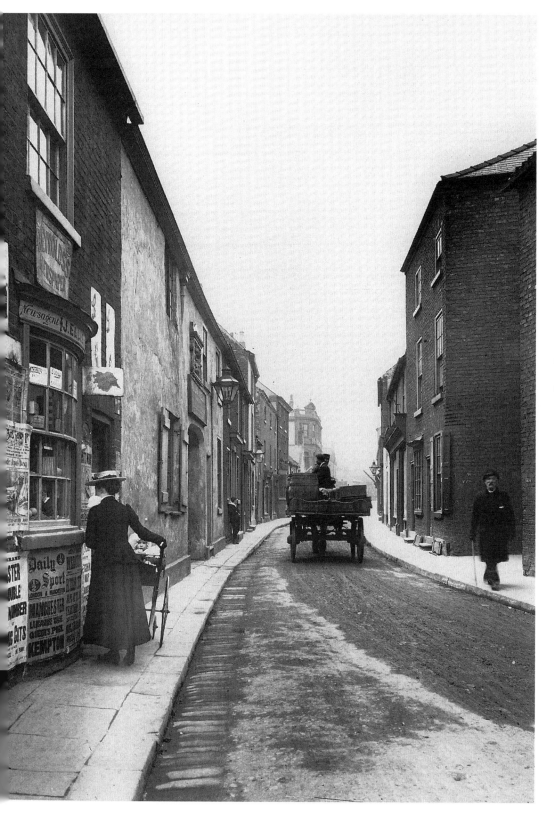

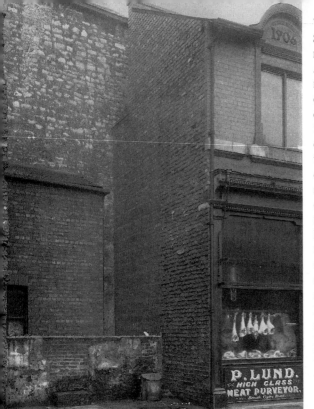

Work taking place for the widening of Silver Street. P. Lund's butcher's shop is on the right bearing the date 1906.

At the Street Improvement Sub-Committee meeting of 20 February 1906, a Mrs Lund, owner of number three, was awarded compensation and a new property:

'As to Mrs Lund's property that she be offered £125 for 22 square yards of land to be thrown into the street, and as full compensation for the disturbance of her son, the Tenant, the Corporation to pull down the present building and erect on the remaining land belonging to Mr Lund a Lock-up shop with Store room over, cellar in the basement and necessary convenience, and to provide her son with temporary accommodation in an adjoining shop during the reconstruction of the premises, Mrs Lund giving the Corporation possession of the present premises when required.'

Local firm Chas Sprakes & Sons built Mrs Lund's new premises for £275.

Work taking place for the widening of Silver Street; the Danum Hotel may be seen on the left. Once the Silver Street widening was completed, the opposite side's property owners were seemingly encouraged to alter their premises, as much rebuilding and redevelopment work took place. Arguably the most notable was the Palace Theatre's (later the Essoldo Cinema) construction in 1913.

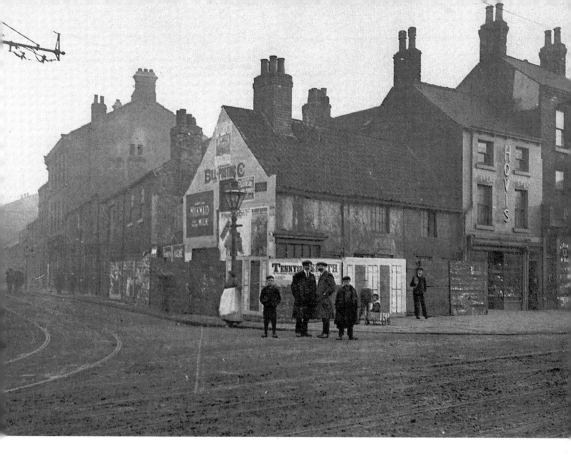

The St Sepulchre Gate and
Spring Gardens corner before the
construction of drapers W. Elland &
Son's store. Note the tramlines for
the Hyde Park tram route.

In 1893 the eastern St Sepulchre Gate
and West Street corner was rebuilt.
The picture here shows part of the
property that existed at the junction
prior to that work taking place. New
property constructed on the site
was occupied for a time by S. Morris,
paperhanger, and subsequently by
May & Son. A sign on one of the
windows says: 'Chairs rebottomed
here.'

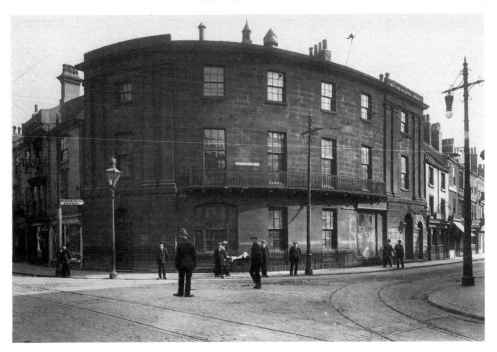

The High Street and St Sepulchre Gate junction before the start of the thoroughfare's widening. The large building dominating the picture is the Gentleman's newsroom and library.

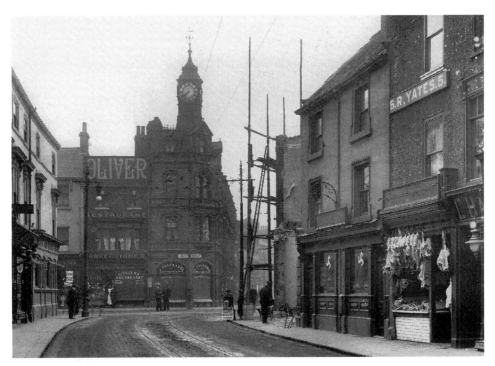

St Sepulchre Gate facing the clock corner. Work on the widening of St Sepulchre Gate and the clearance of the Gentleman's newsroom and library is taking place on the right. Next in line for clearance and setting back will be the Three Legs public house and R. Yates' business premises.

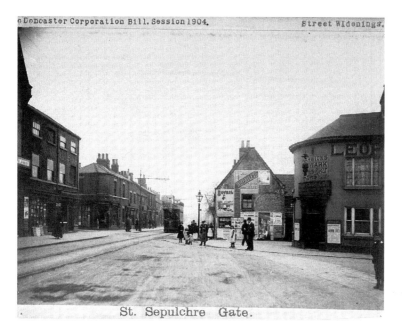

St. Sepulchre Gate.

St Sepulchre Gate, looking west from one of Bagshaw's original prints that were commissioned by Doncaster Corporation for use in their Street Widening Bill of 1904. The picture shows the St Sepulchre Gate and West Street corner (right) before widening. As a result, the Leopard Hotel was set back.

Following the Baxter Gate and the Old Theatre site improvements, the Corporation focussed its attention on widening Sunny Bar, the eastern entrance to the Market Place. Besides providing a more convenient thoroughfare for market day traffic, the changes were also intended to accommodate the construction of the Beckett Road and Avenue Road tram routes.

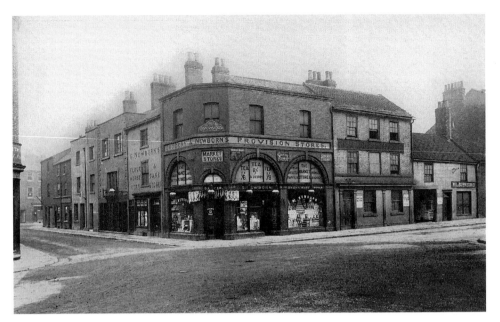

In this picture the buildings as far as Wilburn's saddle shop were demolished for the Sunny Bar widening. G. Newborn, grocer, who had traded on the corner of the Sunny Bar and Market Place from at least the late 1880s, acquired new property in the Sunny Bar development. The derelict building standing adjacent is the Black Swan Inn and following the demolition the licence was transferred to the 'Plant Hotel' at Hexthorpe. The saddler had only occupied his premises for a year prior to the implementation of the improvement scheme and consequently moved his business to No. 29 Market Place.

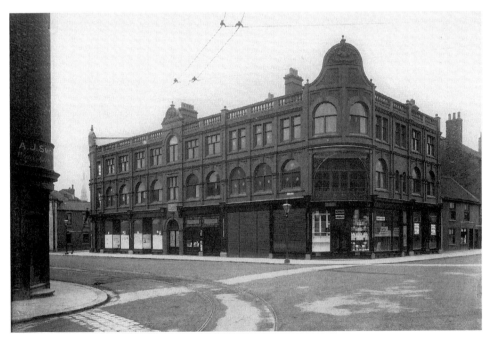

This photograph shows the widened Sunny Bar together with the buildings constructed on the remainder of the site by local builder Dennis Gill.

The junction of Silver Street and Sunny Bar. On the left, amongst an assortment of wall posters, is the entrance to a large stable yard situated at the rear of the Black Swan Inn. In the coaching days the stables provided room for at least thirty horses.

W. Swaby, whose hairdressing business is advertised in the corner window, did not retain the position he occupied in Sunny Bar after the improvements, moving first to East Laithe Gate and later to Market Road.

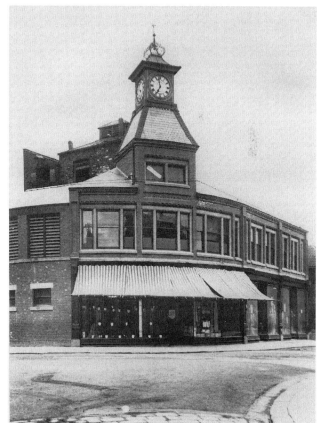

Improvements at the Sunny Bar and Market Road corner.

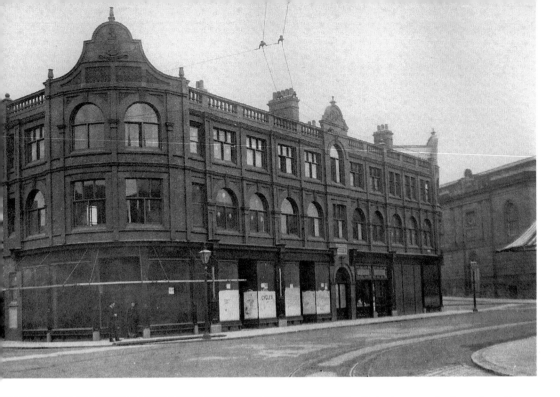

This photograph shows how the scene has altered from the one on the previous page. The old ramshackle buildings have been cleared and replaced by ones that are impressive in character and which offer more shop accommodation for traders.

The old waterwheel near North Bridge, the Brown Cow public house is in the distance on the left.

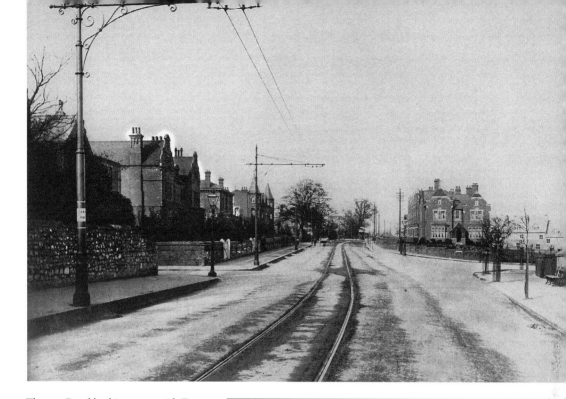

Thorne Road looking east with Town Moor Avenue to the right and St Mary's Road to the left. The picture shows the Thorne Road section of the Avenue Road tram route. Beyond the terminus at this time, there was nothing more than fields and farm buildings. After trams were withdrawn from the service in 1925 they were replaced by motorbuses on an experimental basis; the route was also extended along Thorne Road into the new estates under construction at Wheatley Hills. The motorbuses operated for seven years, being replaced by trolleybuses in 1931.

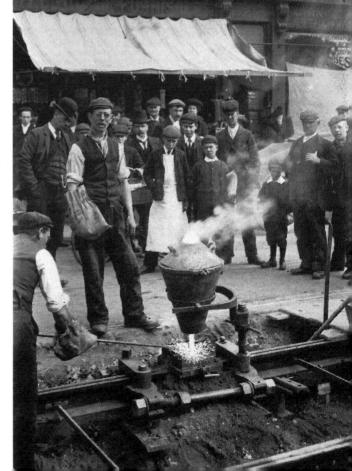

Work taking place on the tram track in St Sepulchre Gate.

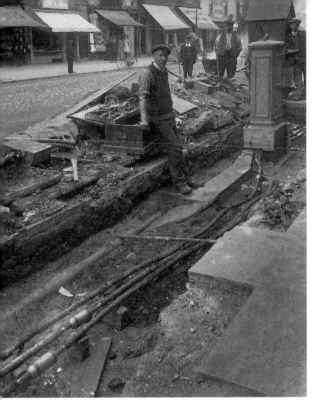

Workmen take a break whilst posing for Luke Bagshaw in St Sepulchre Gate. In the background on the right is the Queen's Arms Hotel.

The Doncaster Corporation Tramways Electric Car Shed in Greyfriars Road. On 2 June 1902 the Mayor of Doncaster, Thomas Windle, formally opened the tram shed door with an 18-carat gold key. St George's Church can be seen in the background.

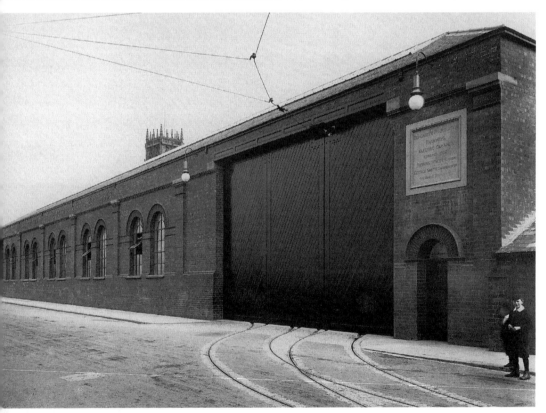

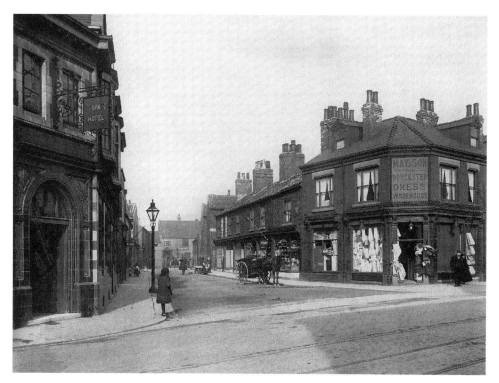

In 1893 the eastern St Sepulchre Gate and West Street Corner was rebuilt. Sixteen years later the western corner was altered and the improvements of both street corners can be seen here.

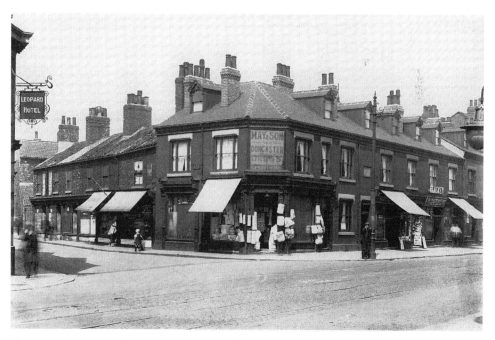

Another view of the West Street and St Sepulchre Gate corner improvements featuring May & Son's business premises.

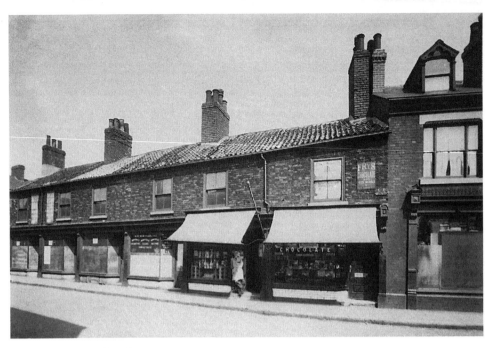

Old properties on West Street.

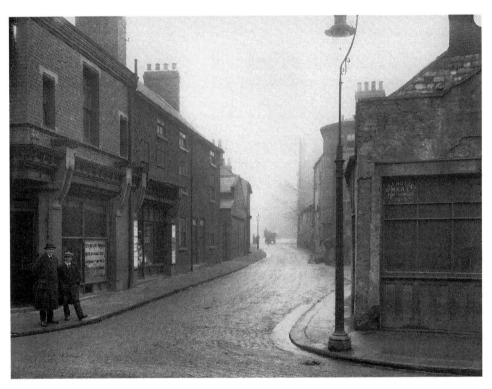

Wood Street looking towards Waterdale before its widening and the removal of properties on the right. One of these was the Wood Street Hotel, the license being transferred to the Park Hotel, Carr House Road.

4

TRANSPORT

It was in the very early days of motoring that the firm of E.W. Jackson & Son Ltd was started in Doncaster, and in 1904 the Hall Gate showrooms were built. About 1912, Messrs Jackson entered the car manufacturing field and the parts of their Cheswold car, from the smallest nuts to chassis, were made at the French Gate premises. Bagshaw did a certain amount of work for Jacksons and their Cheswold Motor Ambulance is pictured by him near the old Doncaster Technical School.

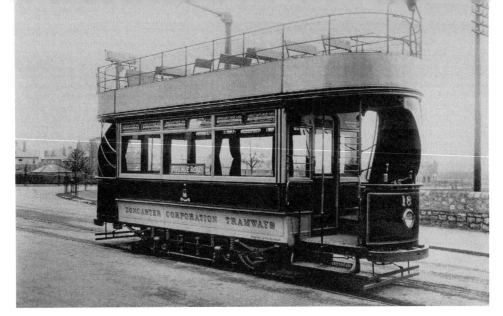

Luke Bagshaw took photographs of Doncaster tramcars for the manufacturers Dick Kerr Co. and for Doncaster Corporation Tramways Department, which purchased them. Car No. 18 is pictured shortly after being purchased in 1903 at the junction of Town Moor Avenue and Thorne Road. Until this time the Corporation had been unwilling to allow advertisements to spoil the pristine crimson and yellow livery, later however they allowed glass transparencies to be placed in the upper windows of the lower deck. This type of tramcar provided no protection for the driver or conductor against the weather. If no passengers were being carried on extremely cold winter mornings, some drivers and conductors, leaving the tram to operate independently, jogged alongside the vehicle in an effort to keep warm.

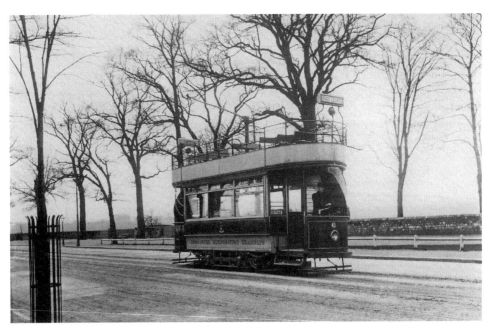

Car No. 6 is seen in Bennetthorpe whilst operating on the Race Course route.

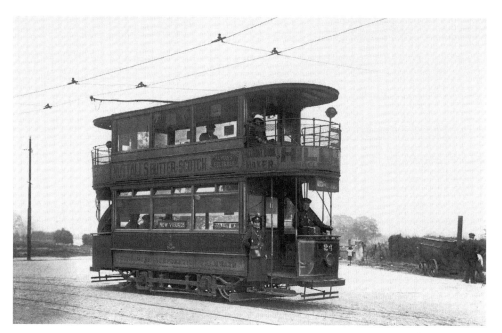

The extension of the Bentley tram route to near the colliery in 1924 was one of the last additions to the Doncaster tram network. Having just left the terminus, Car No. 24, (purchased with five other tramcars in 1904) was photographed by Luke Bagshaw on the 'passing loop' near the junction of the Avenue and Arksey Lane.

Prior to the opening of New Bridge in 1910, the Bentley trams, when they needed major repairs, were towed by a steam roller over the Great Northern Railway's level crossing to the Greyfriars Road depot. Luke Bagshaw took this picture shortly before the wiring for tram operations across the North Bridge was completed. It also shows the original Bentley tram terminus in Marsh Gate.

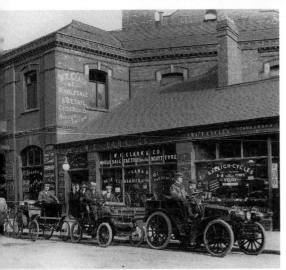

William Edwin Clark, motor engineer of Station Road and Hall Gate Doncaster, and agent for leading automobile and cycle manufacturers, was born in 1862. A native of Derby, he was brought up to the engineering craft, and as a youth was with General Gordon in Egypt, engaged in assembling boats for use on the Nile. He came to Doncaster in the late 1880s and was employed in the GNR Railway Works on the Carr. He was an ardent cyclist, and became a member of the Doncaster Wanderers Cycling Club. Whilst still at work on the Carr, he became agent for a Wolverhampton firm of cycle manufacturers, and about 1888 commenced a cycle sale and hire business in a small shop at Bennetthorpe. He joined forces with a Mr Brown, a retired engine driver. Another shop was opened in Hall Gate, to which William devoted most of his time and attention.

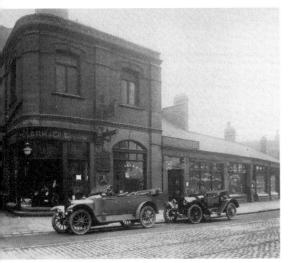

Around the late 1890s Messrs Clark and Brown took over the old flour mill in Station Road from George Parkinson, which became the headquarters of the firm's operations. Brown died several years after the opening of the Station Road shops. Clark acquired the freehold of the Station Road property after the First World War. He became the chairman of the Doncaster branch of the Motor Trades Association and a founder member of the Rotary Club of Doncaster. Clark was interested in the Doncaster Technical College, and gave a shield and medals for competition in the engineering section. He was also a member of the Juvenile Employment Advisory Committee. He died in 1932 and his business was eventually taken over by Edwards Motors. The old Station Road premises were demolished during the re-development in the area during the 1960s.

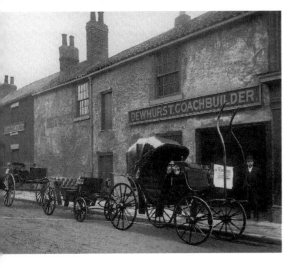

Dewhurst's coach-building premises on Cleveland Street.

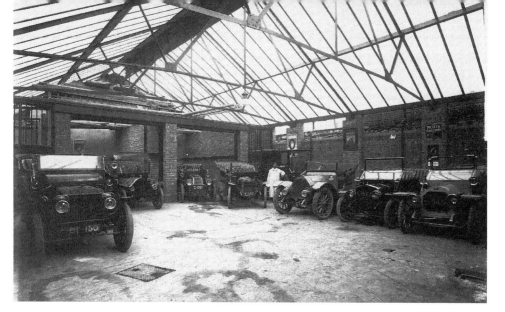

An interior view of a garage where a fine array of vehicles is on display.

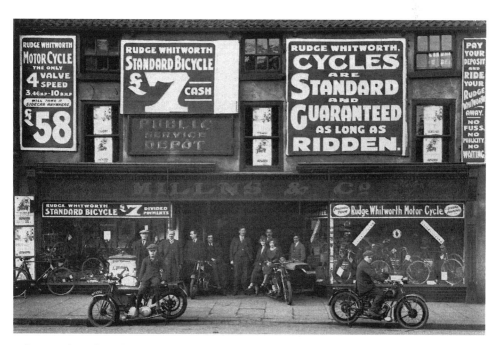

Milns & Co.'s cycle and gramophone shop in St Sepulchre Gate. Later, the company moved to premises in High Street. The *Doncaster Chronicle* of 30 March 1933 had the following to say about the move: 'Last week witnessed the transfer of the business premises of a well-known Doncaster firm to another part of the town. We refer to Messrs Milns & Co., the cycle agents and dealers, and wireless experts, who for the last 20 years have been closely identified with the business life of St Sepulchre Gate. Here for two decades they carried on a flourishing and rapidly extending trade first at no. 165 and later at Nos 92-94 St Sepulchre Gate. Last week they removed to more commodious and more central premises at no.9 High Street, two doors from the Picture House.'

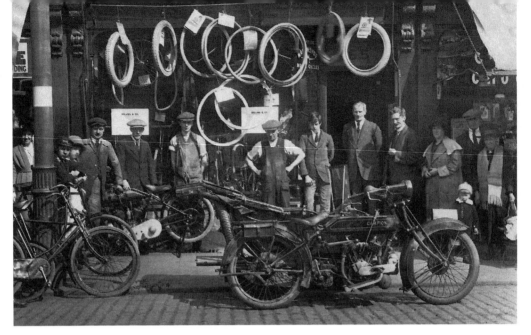

Milns & Co.'s premises.

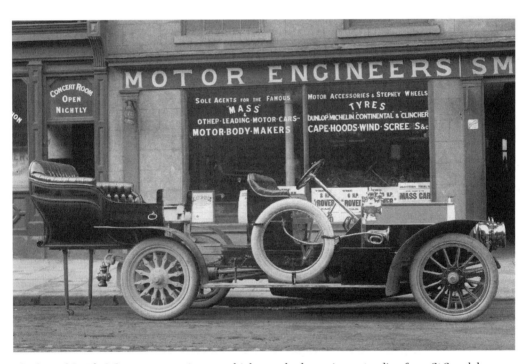

The firm of Smith & Son, motor engineers, which once had premises extending from St Sepulchre Gate through to West Laithe Gate, was established by George Smith in 1805. Under the control of successive generations of sons, it flourished until becoming one of the best-known coach-building businesses in the country, employing a large number of men. The firm built the coach used by the High Sheriffs of Yorkshire. As each successor to the office was appointed, the coach was sent to them to have the new coat of arms painted on it, and to be generally re-decorated.

The firm also earned a reputation for its carriage horses and, whenever royalty visited Doncaster, Smith & Son provided the horses and in some cases the carriages too. With the advent of the motorcar, the firm adapted their business and works to the changing needs of the period. From time to time the St Sepulchre Gate premises were enlarged until, on the formation of a limited liability company 1922, it was necessary to move to more commodious premises in Hall Gate and Waterdale.

An ambulance outside Smith & Son's premises.

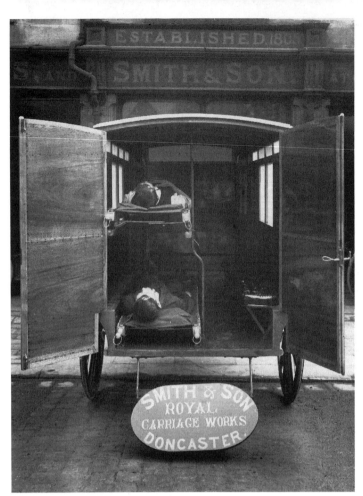

Left: An interior view of an ambulance outside Smith & Son's premises.

Below: Charles Graham Steadman was born in Mattersey and came to Doncaster in 1873, taking over Edward Mimmack's Princess Street cab and coach business.

In 1877 Steadman's younger brother John established himself as a horse breaker in Silver Street, but later entered the cab and coach business himself. The two brothers competed during the late nineteenth century: Charles dying in 1904 and John in 1922. For a time Charles Steadman's base remained in Princes Street, but his brother moved via Silver Street, Highfield Road, Cleveland Street and finally to premises in Balby Road. The photograph shows one of Charles Graham Steadman's four-in-hand wagonettes alongside the racecourse.

Charles G. Steadman, whose premises are seen here in Princes Street, proudly adopted the 'By Royal Appointment' badge after carrying Queen Victoria's son, the future Edward VII, to Doncaster racecourse meeting. The business was expanded by Charles' son, Frank, and later when Phillip Steadman and his brother Dennis took over a fleet of cars was introduced. Not long after Philip's death in 1985 the Princes Street business closed.

Doncaster Corporation Tramways Department's track cleaning car. When Arthur Pinkney gave me this plate I noticed the background was 'painted out.' So eager to see what this concealed, I carefully cleaned it off. Disappointingly it only revealed a brick wall.

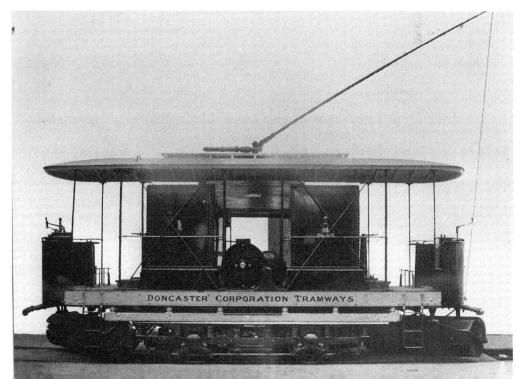

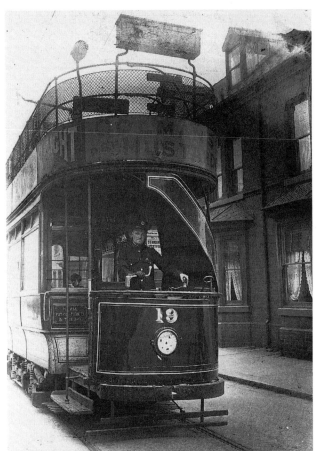

The driver of tramcar No. 19 poses for the camera at Childers Street, the location of the Hyde Park outer terminus. Initially, the outer terminus was at Jarratt Street (Hyde Park) but was moved to Childers Street in October 1902. Although the glass plate is flawed, it is an interesting record nevertheless.

Tramcar No. 11 is pictured approaching Baxter Gate on its return journey from Avenue Road. The Avenue Road and Beckett Road tram routes shared the same track as far as the junction at Broxholme Lane. From there the Avenue Road route continued along Highfield Road, turned right at King's Road and then followed Thorne Road to the terminus at the 'southern end' of Avenue Road. Both outward and return journeys took twelve minutes, though the service was underutilised with some journeys attracting only two or three people.

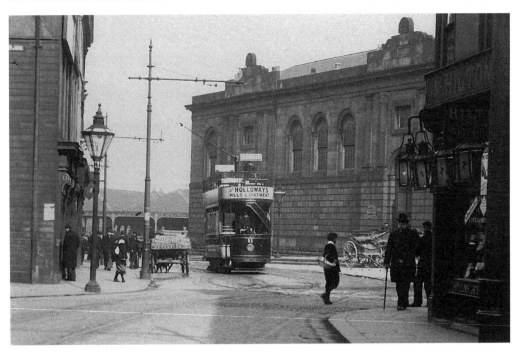

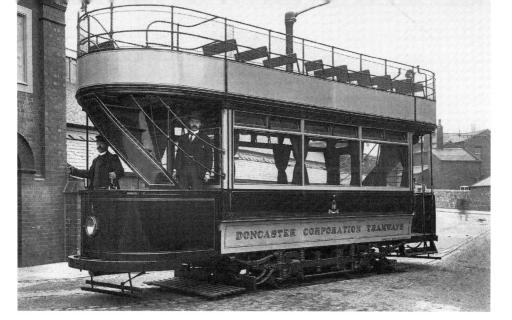

Here is car No.1 shortly after delivery at the entrance to the Greyfriars Road tram depot. The man on the right of the photograph is probably Mr Wyld, the tramways' manager from 1902-4. Cars Nos 1-25, bought in three batches in 1902-3, had 'open top' and 'ends', which at the time were almost universal tram features. Various firms, including Cravens of Sheffield, had submitted tenders to build Doncaster's trams, but the contract went to Dick Kerr of Preston, who later supplied the entire fleet, except No. 37 bought second hand from Erith in 1916.

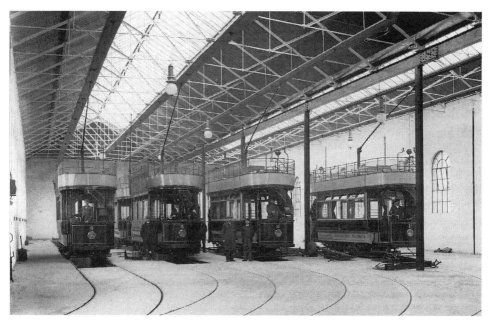

The interior of the Greyfriars Road Electric Car Shed in 1902 showing five of the fifteen cars that were purchased in that year. As the trams were gradually phased out, the shed was converted between 1928 and 1931 for trolleybus operation. Finally, after changing ownership several times since its former use, the shed was demolished during the early months of 1983.

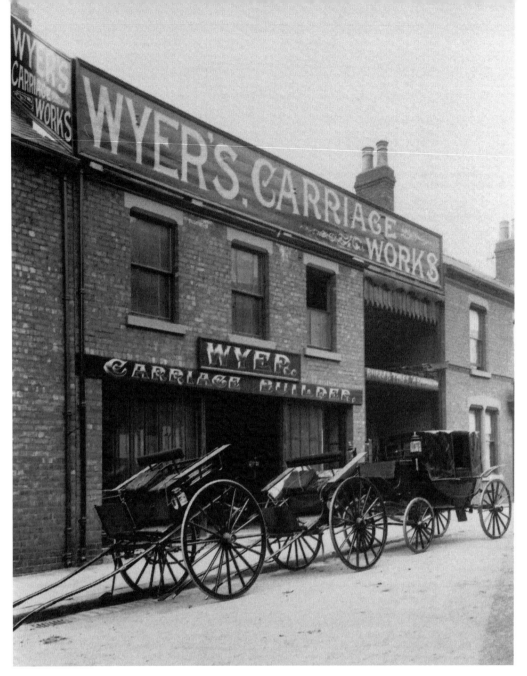

It was said that highly esteemed local tradesman Isaac Wyer passed away with 'tragic suddenness' on 17 March 1912 at the ripe age of seventy-eight. He was cheerfully working at his bench in the morning, and then at around 10.30 suffered a fatal heart attack. He was a native of Harlaxton near Grantham. He came to Doncaster around 1870 and started a business as a smith and wheelwright in East Laithe Gate, on the premises where he had the fatal seizure. Some years earlier his second son A.G. Wyer had opened up on the opposite side of the street in the motor car and carriage building industry. His eldest son became a mining engineer in South Africa. Isaac Wyer never took an active part in public affairs but it was said that he was of a genial disposition, and would be missed by a large circle of friends.

Printed in Great Britain
by Amazon

69373669R00075